CONTENTS

	Foreword and some Explanatory Notes	4
	Introduction	6
1	Wales and the Source of the Hafren	13
2	The Marches and Shrewsbury	29
3	Cressage to the Ironbridge Gorge	46
4	Bridgnorth to Bewdley	61
5	Stourport-on-Severn to Upton-upon-Severn	81
6	Tewkesbury to Gloucester	104
7	Sharpness and the Severn Estuary	119
	Further Information	127

FOREWORD AND SOME EXPLANATORY NOTES

Common with most rivers the Severn has an upper, middle and lower course, often referred to as a 'young', 'middle-aged' or 'old river' life cycle. The photographs and descriptions in this book – collected over a number of years – depict the Severn's three-stage life cycle and further illustrate the regional geography, history, changing seasons and mood of this iconic river. The route and journey through the three ages of the Severn is best followed and explored on foot, which requires no more than moderate exertion, as each stage can be tackled in short or day-long excursions. The points of access to the river, centres of population, public transport, accommodation, hostelries, and places to rest vary with location, but they are never more than a few miles from the river. Armed with the appropriate OS maps, GPS, a good pair of walking boots and waterproof clothing, the journey along the route of the Severn should prove enjoyable and rewarding. This book describes a journey from source to sea, and starts with the young Severn's narrow and fast flowing upper course in the Cambrian Mountains of Wales. From here, the Severn passes through sparsely populated countryside spotted with a few inhabited centres, before crossing the border into England. Reaching 'middle age', the river meanders and flows at a much slower pace into the county of Shropshire before crossing the county boundary into Worcestershire. The Worcestershire Severn flows through the city of Worcester and on entering Gloucestershire, where it passes through Gloucester – the second city on the Severn's journey to the sea. Beyond this point, the river rapidly ages to become a slow flowing and tidal 'old river'. Here the Severn's lower course has treacherous tidal currents, protruding rocks and sand banks, for centuries a hazard to any vessel attempting to reach the upper reaches of the river. Downstream of Sharpness and Avonmouth the river widens into its sandy tidal estuary at the end of its 220-mile (354 km) journey from source to the sea.

Most of the photography in this book is taken using direct digital camera image technology; some older images are from the author's own photographic negatives, and old prints are reproduced from the author's personal collection

of ephemera, postcards and prints. The maps are surveyed using a handheld GPS, and the route and all the locations of the photographs are relatively easily accessible from public roads, public rights of way, and well-established footpaths; especially the 'Severn Way', the well-signposted long-distance path that follows the river closely for almost its entire course. Other long-distance paths, cycle ways, local footpaths and bridleways, including some quieter roads, also allow access to the river and reference is made to them in the text. Finally, a cautionary note, please consider your safety near open water and respect the access rights, be aware of the countryside code (copy downloadable from the Natural England GOV.UK website), also remember that some locations are relatively isolated so allow plenty of time to cover a route.

<p align="right">Jan Dobrzynski,
Kidderminster 2015</p>

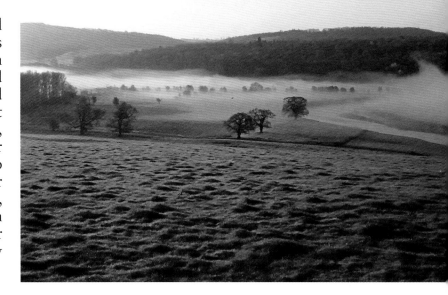

Early morning mist at Buildwas, seen from the Leighton Road.

INTRODUCTION

At 220 miles (354 km) from its source to the sea, the Severn is the second longest river in the British Isles; it is five miles longer than the Thames and two miles shorter than the River Shannon in the Republic of Ireland. The Severn is a deceptively young river; less than 10,000 years of age, although its course takes it over incredibly ancient rock, spanning geological ages and hundreds of millions of years. Before the advent of the last great ice age, the former Severn flowed in a very different direction; it was substantially shorter in length and flowed northwards into the Irish Sea to an estuary between the Wirral and North Wales. The Devensian ice age lasted around 30,000 years, and during this entire time, an impenetrable barrier of ice blocked the Severn's former northerly course simultaneously erasing almost all trace of the earlier river. The captured and frozen waters of the ancient river Severn merged with the flow of the vast continental glacier and eventually emerged as streams and rivulets of summer melt-water from underneath its southern boundary. Finally, as this huge continental ice sheet receded and melted at the end of this ice age, a proglacial lake formed below the receding glacier. Bound by the glacier's frozen face and the steep Shropshire hills to the west, the new river Severn was inexorably forced onto a more southerly course through an overspill channel into an already formed glacial valley, cutting an ever-deeper channel in the underling rock to form the Ironbridge Gorge. When the ice age finally ebbed away around 10,000 years ago, a rich and diverse natural habitat evolved in the new Severn Valley, ideally suited to habitation and human activity, and in the following centuries came farming, agriculture and industry.

Throughout human history, the Severn served as a natural boundary between cultures and countries, and for centuries it was the principle route for the transport of goods and people, throughout the Neolithic and Bronze Ages up to the Roman occupation, a boundary to a Saxon Kingdom, and a route for Viking and Norman invaders.

Topographically, the source of the Severn lies at 2,001 feet (610 metres) above sea level on the north-eastern

slopes of Pumlumon Fawr part of the Plynlimon massif in the Cambrian Mountains range of mid-Wales. Called by its Welsh name Afon Hafren, the young upper Severn passes through rich sheep-rearing hillsides: Llanidloes, Lladinam, Caersws, Newtown and the market town of Welshpool, before crossing the Marches into England and Shropshire. The Severn was once navigable from Welshpool, and small boats could navigate these upper reaches of the river free of charges and local taxes. It is here that the Severn reaches the next stage of its life cycle.

Now reaching 'middle age' the slower flowing Hafren sheds its Welsh name to become the Severn as it meanders into Shrewsbury, the county town of Shropshire. The town was once a border stronghold founded in medieval times, and it offered protection during the centuries-long conflict between the Welsh and English from the confines of a natural loop in the river; for much of its length the Severn formed the natural boundary between the two countries. The upper reaches of the river through Shropshire were always difficult to navigate as water levels varied dramatically with the seasons, and boats had to be towed by teams of men, dragging vessels across shallow shoals. Despite these difficulties, by the mid-eighteenth century coal, salt, iron, minerals, stone and timber was being moved in the upper regions of the Severn as far up river as Pool Quay in Welshpool, and vessels of up to 40 tons could reach Shrewsbury.

It is quite probable that the Romans also used the river for the transportation of goods. Beyond the

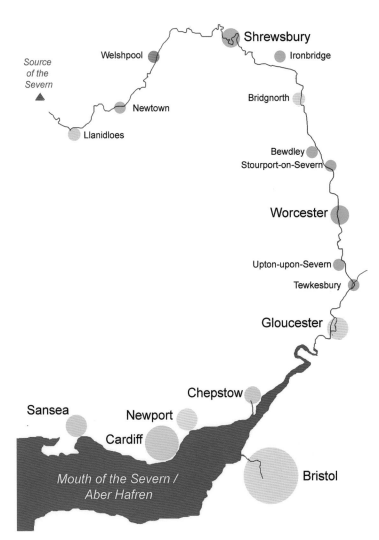

abandoned Roman city of Viroconium, whose Latin-speaking inhabitants called the river Sabrina, the course of the river Severn snakes eastwards through the villages of Cressage and Buildwas, home to a ruined Cistercian abbey and twentieth-century coal-fired power station. The Severn then enters the Ironbridge Gorge, the cradle of the Industrial Revolution, which was once a navigable artery for trade in raw materials and manufactured goods: timber from Montgomeryshire, iron from Coalbrookdale, and pottery from Coalport and Jackfield. Trading vessels of up to 60 tons served the Gorge; the typical cargo boat was the 'Upstream Trow', its name distinguished it from the larger 'Downstream Trows' that used the tidal portion of the river below Worcester. These larger vessels were used to transport ironstone, grain, salt from Droitwich and coal from the Forest of Dean.

For a time in the nineteenth century the railways, and the canals a century earlier, heralded an increase in trade and commerce to the Severn Valley, and prompted the commercial and industrial expansion of the Ironbridge Gorge. The ancient river trade kept pace for a time with the insatiable demand for moving minerals and manufactured goods, during the period that came to be known as the Industrial Revolution. By the dawn of the twentieth century, things began to change, and industrial growth turned into decline. Together with the demise of riverside industries such as iron foundries, shipbuilding and milling, and with the ease of ever-cheaper railway transportation, the once prolific commercial river trade serving the upper Severn above Stourport-on-Severn fell into terminal decline. Although commercial river traffic remained on the lower stretches of the Severn well into the twentieth century, some commercial traffic remains in the Severn estuary in this century.

During the latter part of the twentieth century following the decline of the heavy riverside industries, quarrying and mining, the Severn underwent a period of noticeable change. Large stretches of once denuded valley sides and bare towpaths of former industrial riverside embankments reverted to nature. Today the river is cleaner, in part more forested and flanked by rich farmland. In the lower reaches of the river industries and ports remain, but along the whole of the Severn a more noticeable human activity is apparent in the widening and building of road bridges to accommodate the motorcar and commercial vehicles, while housing developments increasingly encroach onto the flood plain and river terraces in urbanised areas of the river.

The former river port of Bridgnorth is home to the preserved Severn Valley Railway that follows the course of a particularly picturesque stretch of the river to Bewdley in Worcestershire. Ironically, the railway that once displaced the Severn River trade at Bridgnorth itself became a casualty of another more expedient form of transport and competition from roads, and the SVR closed progressively from 1963 onwards. Still in Shropshire, the Severn meets Hampton Loade, a well-known stopping-off point on

Above: The young Afon Hafren makes its way down from the slopes of Plynlimom/Pumlumon Fawr.

Right: The Severn Way, the long way-marked path follows the Hafren/Severn from source to sea.

the Severn Valley Railway. Served also by a part-time walk-on ferry, which happens to connect two riverside pubs on opposite banks of the river, as well as connecting the SVR station and the grounds and house of the National Trust property of Dudmaston Hall, also on opposite sides of the river.

In Worcestershire, the river meets Upper Arley the Bewdley a Georgian riverside town and former river port. Further down river is Stourport-on-Severn, a town that owes its very foundation to river transport and the canal age. The town is still a popular location for daytrippers from the industrial Midlands and the Black Country who at one time arrived in their thousands by rail, road and tram to visit this riverside resort. The more adventurous travelled on river steamer trips to Holt Fleet, Worcester, or even as far as Tewkesbury or Gloucester, returning home by omnibus, charabanc or railway train. The Victorian and early Edwardian golden age of the river steamer has sadly passed into history, but the river steamer has not disappeared entirely. There are still many different sizes of passenger boats available for day trips and hire for special occasions on the navigable section of the river below Stourport. The river steamers are not restricted exclusively to the lower reaches of the river, not excluded are isolated sections of the river at Ironbridge and Shrewsbury where steamers ply short lengths of navigable river.

The mid-1840s saw the building of locks and weirs at Stourport, Worcester and Gloucester ostensibly to improve the navigation of the lower Severn. However, this did little to curb the inevitable decline of river transport above Stourport-on-Severn, as the improvements did not extend upriver of the town. In fact, the improvements probably hastened the demise of river trade in this upper region of the Severn and this part of the river now remains lost to commercial and pleasure craft navigation. Today the Severn is navigable along part of its length between Stourport-on-Severn and Gloucester, and vessels can pass through Lincomb, Holt Fleet, and Bevere locks to the city of Worcester at Diglis locks, and Tewkesbury locks to Gloucester. On leaving Upton-upon-Severn and Worcestershire, the Severn enters Gloucestershire where the river Avon at Tewkesbury joins it and marks the point at which the river reaches the final part of its life cycle: old age. The river parts and rejoins as it skirts Gloucester. The upper easterly arm of the river joins the Gloucester & Sharpness canal built to circumnavigate treacherous tidal currents, rocks and sand banks of the tidal Severn. The lower arm from Upper Parting splits the Severn onto a westerly route to Maisemore weir and the old lock to the estuary. The land bound by the two channels of the Severn is known as Alney Island and consists mostly of low-lying farmland.

Before the Severn Commission's Severn locks were constructed between 1843–58, and the building of the Gloucester & Sharpness Canal, which opened in 1827, the 'Downstream Trows' carried the commercial river traffic

to and from the Severn Estuary, navigating through the particularly dangerous stretch between Gloucester and Berkley.

From Minsterworth the Severn flows through the Vale of Gloucester and the Vale of Berkeley with Westbury-on-Severn and Newnham on its western bank. At Frampton-on-Severn, the river widens into its estuary, on the eastern bank is the docks at Sharpness, and further down river Avonmouth dock, on the opposite bank the harbour at Lydney, and the Forest of Dean. Now, at the end of its journey, the Severn is joined by the river Wye emerging at Chepstow, both rivers are crossed by the iconic M48 road bridge and crossed again by the M5 suspension bridge. After a further 5 miles, the Bristol Avon enters the shared Severn Estuary at Avonmouth to mark the end of the Severn's journey from source to the sea.

Above: A timeless scene, cattle watering on the banks of the Severn.

Below: The riverscape at Upper Arley Worcestershire.

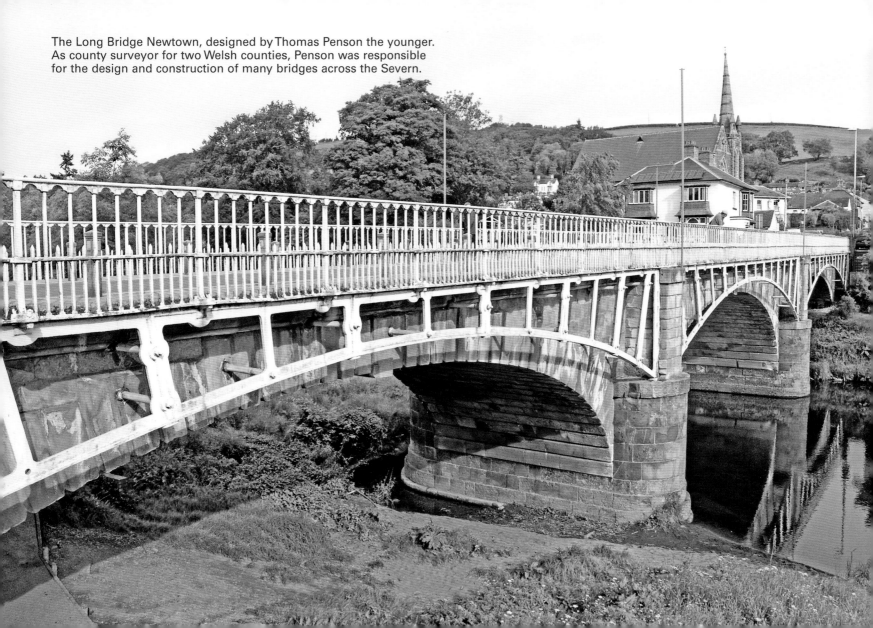

The Long Bridge Newtown, designed by Thomas Penson the younger. As county surveyor for two Welsh counties, Penson was responsible for the design and construction of many bridges across the Severn.

1

WALES AND THE SOURCE OF THE HAFREN

In keeping with the three-stage life cycle of most rivers, the youthful Afon Hafren (Severn) emerges from a boggy spring on the north-eastern flank of Plynlimon (Pumlumon in Welsh) in the Cambrian Mountains of Wales. Pumlumon is the largest watershed in Wales and is the source of two other rivers, the Wye and Rheidol. The young Severn is a rapid, narrow and fast-flowing river for most of its journey through Wales, as it merges with its tributaries to expand and increase in volume. The river's path through Wales takes it through a varied landscape formed predominantly of grassland and meadow, which offers some rough grazing, along with some agricultural or fallow land and areas of woodland and forest. The topography is dominated by the Cambrian massif and steep surrounding hillsides flanking the deeply cut glacial valleys of the Severn's catchment. The principal towns and villages that lie along its course through Wales are Llanidloes, Lladinam, Caersws, and the market towns of Newtown and Welshpool. The river's fast current eventually slows to a more sedate pace as it crosses the border into England, where it becomes a 'middle-aged' river.

PUMLUMON FAWR AND THE HAFREN FOREST

The source of the Severn lies in a deepwater-laden bog on the exposed north-eastern slope of the Plynlimon massif – it can only be reached on foot. The small rivulet which forms at the source in a little over three miles becomes a fast flowing stream, gathering momentum as it drops a thousand feet through dense forest and over rocky terrain, over rapids and waterfalls to the Hafren-Torri-Gwddff waterfall. Located in the modern Welsh county of Ceredigion, Pumlumon in Welsh means 'five peaks' and it is the highest point in mid-Wales. The massif is part of the Cambrian Mountains, which comprises of the principle summits Pen Pumlumon Fawr 2,467 feet (752 metres), Pen Pumlumon Arwystli 2,427 feet (740 metres), Pen Pumlumon Llygad-bychan 2,384 feet (727 metres), Y Garn 2,2434 feet (684 metres) and Pumlumon Fach 2,191 feet (668 metres). The peaks are part of what was once referred to as the 'Green Desert of Wales' this trait of land remains desolate, inhospitable and inaccessible.

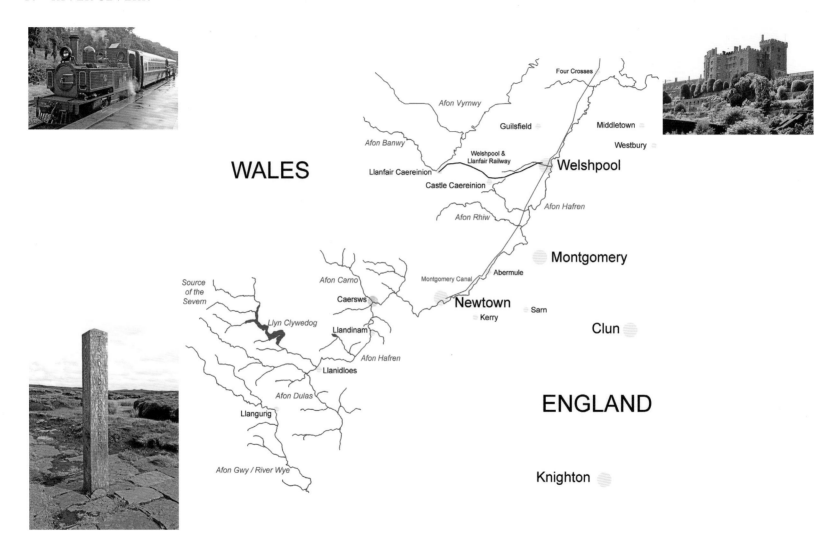

Opposite top left corner: The Welspool & Llanfair Railway a narrow-gauge railway owned by the Cambrian Railways, which served towns and villages on the Afon Hafren in mid-Wales.

Opposite top right and below left corner: Powis Castle, Welshpool, made the transformation from medieval fortress to world-famous garden and tourist attraction.

Right: Decking allows easy access to the source of the Hafren/Severn through the boggy terrain of the Hafren Forest.

Anyone who wishes to lay claim to walking the whole length of the River Severn from source to sea would have to start his or her journey by first walking to this isolated spot from the nearest public road or car park. Fortunately, a well-paved path and wooden decked walkway ascends to the source of the river from Rhyd-y-benwch car park and picnic area in the Hafren forest. The final mile is along a stone-paved path, and across individual stepping-stones, that traverse the soft, spongy and saturated ground. A solitary wooden post marks the source of the river Severn on Pumlumon Fawr 2,001 feet (610 metres) above sea level. Carved into each side of the weather beaten post in English and Welsh are the inscriptions 'Source of the Severn' and *Tarddiad Afon Hafren*.

The River Wye (Afon Gwy in Welsh) headwaters are two miles southwest of the source of the Severn, and the Wye has to flow 134 miles in a southerly direction before it actually meets the Severn. The Wye joins the Severn estuary just below Chepstow. Two long-distance footpaths closely follow both rivers from source to sea. The Severn Way and the Wye Valley Walk both meet at Rhd-y-benwch car park and picnic area in the Hafren Forest. Pumlumon's third principle river is the Afon Rheidol; a short fast-flowing river that emerges in its estuary at Aberystwyth, a little over 19 miles from its source in Nant-y-moch resevoir. In English the 'pig's stream' is the name given to

The youthful Hafren makes its way over rapids and through forest.

a small tributary that flowed into the Rheidol valley, now submerged in the reservoir.

In his book *Wild Wales*, the renowned Victorian travel writer George Borrow summed up his experience of visiting Plynlimon and drinking from the sources of its three rivers by quoting lines from a visitor four hundred years earlier:

> From high Plynlimmon's shaggy side
> Three streams in three directions glide;
> To thousands at their mouths who tarry
> Honey, gold and mead they carry.
> Flow also from Plynlimmon high
> Three streams of generosity;
> The first, a noble stream indeed,
> Like rills of Mona runs with mead;
> The second bears from vineyards thick
> Wine to the feeble and the sick;
> The third, till time shall be no more,
> Mingled with gold shall silver pour.

Above right: The north-eastern watershed of Plynlimon/Pumlumon Fawr and the desolate spot that marks the source of the Hafren/Severn.

LLANIDLOES

In little over half-a-mile from the Rhyd-y-benwch car park, the Hafren passes over the Hafren-Torri-Gwddf, known in English as the Severn-Break-its-Neck waterfall. With its waters swollen by a succession of small streams (Nant Maenant, Nant Ricket, Nant Sarn and Nant y Brithdir) flowing from the steep hillsides, the Severn emerges from the Hafren Forest parallel to a country road shared with the Severn Way long distance path. The Severn Way crosses the Severn over a small road bridge to its southern bank. Within 2¼ miles the Severn Way crosses the Hafren again at Felindre Bridge (one of a number of bridges designed by

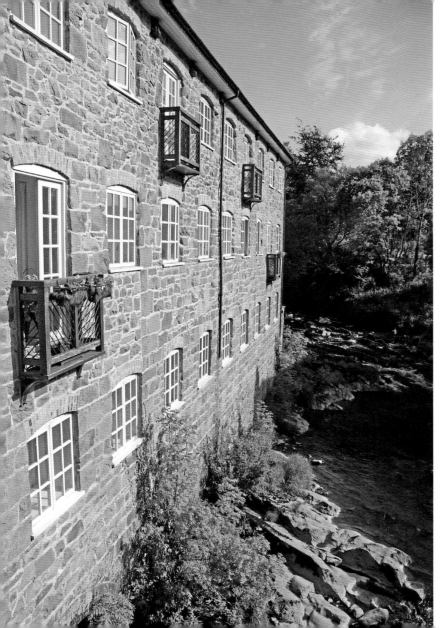
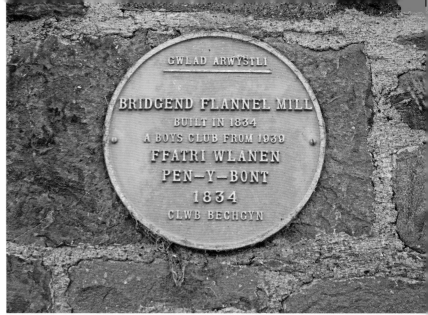
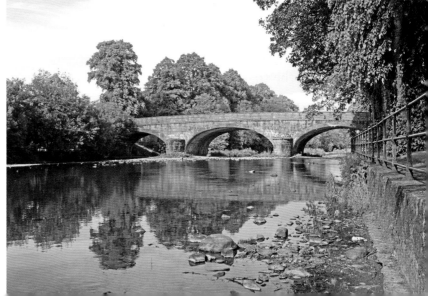

Thomas Penson), at which point the Severn is joined by its first tributary river the Afon Dulas.

The Hafren now flows in a north-easterly direction to its first significant population centre, Llanidloes. Between the town's two river crossings another tributary river joins the Severn from the north in the form of the Afon Clywedog, the town is also the crossing point of two long disatance paths the Severn Way and Glnydŵr's Way. Llanidloes was once the centre of the mid-Wales flannel industry, and there were a number of water-powered mills, in addition to weaving shops, a tannery, and malting in the town. The town hall has John Wesley's preaching stone with inscription 'John Wesley passed through Llanidloes at least six times on his journeys through Wales, and, according to tradition he preached on this stone on three of those occasions in 1748, 1749 and 1764'. The parish church overlooking the Afon Hafren is dedicated to St Idloes, it has salvaged stone arches from Cwm Hir abbey another feature is its hammer-beam roof decorated with carved angels, the tower seen in the photo dates from the fourteenth century.

Opposite Left: Bridge End Flannel Mill on the bank of the Hafren from Llanidloes Short Bridge, designed by Thomas Penson.

Opposite above right: The plaque on Short Bridge reads...

Opposite below right: Llanidloes Long Bridge was also designed by Thomas Penson, the county surveyor for the former counties of Denbighshire and Montgomeryshire.

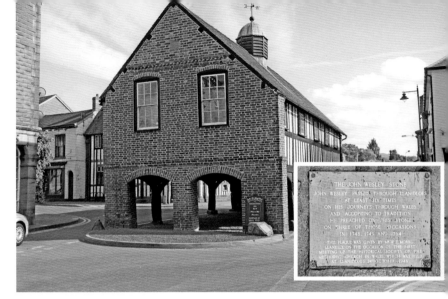

The Old Market Hall in Llanidloes is the only surviving timber-framed market hall in Wales, and the stone where John Wesley addressed his large congregations.

The Severn Way splits from the Afon Hafren at Llanidloes' Long Bridge (1826), the town's other bridge is named Short Bridge (1849), both bridges were designed by Thomas Penson (1790–1859). Thomas Penson (the younger) held the office of county surveyor to the former Welsh counties of Denbighshire and Montgomeryshire. His name is associated with several bridges that cross the Severn, John Fowler, John Gwynn and Thomas Telford are also renowned architects that can lay claim to designing bridges across the Severn. Leaving Llanidloes the Afon Hafren flows 5½ miles in a north-easterly direction

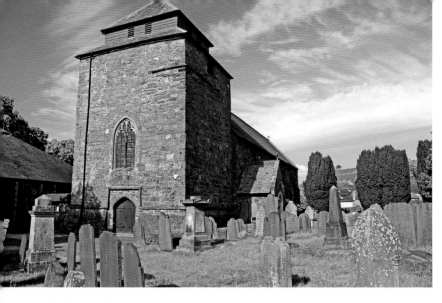

St Idloes' Church, Llanidloes, at the confluence off the Afon Clywedog with the Afon Hafren. St Idloes, was an early seventh-century saint.

towards Llandinam while the Severn Way takes a more northerly and convoluted route over the northern hillside towards Caersws.

LLANDINAM AND CAERSWS

Llandinam village in Powys is located on the A470 and is the family home of David Davies (1818–90) who was a Welsh colliery owner and the founder of the Ocean Coal Co. Ltd, the success of which prompted the construction of Barry Docks in 1889. The Barry Docks & Railway Co. Ltd, was instrumental in developing the Rhondda as a major worldwide exporter of coal. A statue of David Davies stands in tribute to his achievements beside the cast iron bridge he built in 1846, which was also designed by Thomas Penson, David Davies was the contractor. The closed and lifted Cambrian Railways Llanidloes & Newton railway station at Llandinam stood on the east bank of the Afon Hafren, opposite to the village.

The Severn Way can be rejoined at Broneirion Wood or along the lane to the waterworks and Lower Gwerneirin farm. The next habitable centre along the river is Caersws village, on the confluences between the Hafren, Afon Carno and Afon Cerist. The village has a Roman origin, in that it was close to a campaign fort and actually stands on the site of a larger fort and civilian settlement thought to be Mediomanum, which means 'the Central Fist' the fort, guarded a military crossroad and fording point on the Severn. The course of a Roman road has been traced crossing the Severn at Maesmawr Hall Hotel, on the opposite east bank in a loop of the river is the earlier campaign fort at Llwynybrain farm.

Unlike Llandinam, Caersws is still served by a railway, the present day mid-Wales line, formerly the Cambrian Railways Newtown & Machynlleth line – also a junction for the Van Railway – which closed in 1940. The old Moat Lane Junction station was a mile southwest from Caersws, on the east bank of the Severn, an isolated spot that only served as a transfer point for passengers to the

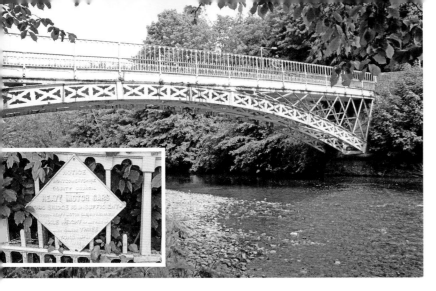

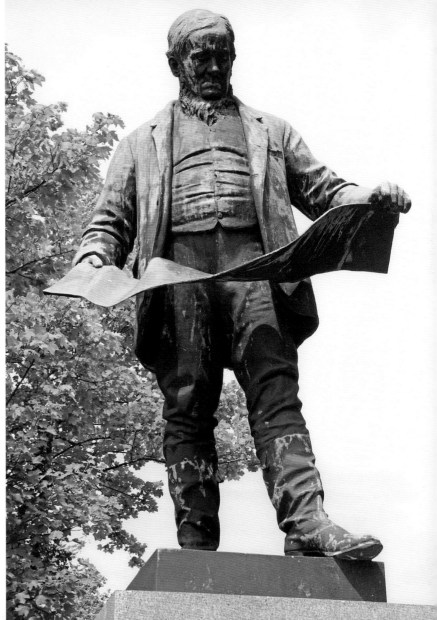

Above: The iron-arched Llandinam Bridge, designed by Thomas Penson.

Right: The statue of David Davies, an industrialist and founder of Barry Docks, stands on the west bank of the Hafren at Llandinam, his home town.

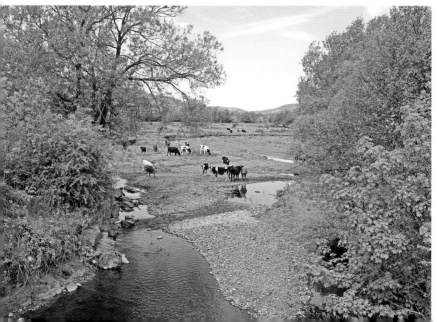

Above: The Hafren flood plain, above Caersws. Crossed by Roman roads, the flood plain was the site of a Roman campaign fort before a more permanent site was found on the site of the village.

Above left: View from the village bridge and the Hafren railway crossing.

Left: A view of the Hafren tributary the Afon Carno as it joins the village at Caersws.

Llanidloes & Newton railway, which closed in the 1960s. The Severn Way once again takes a convoluted route through picturesque sheep rearing hillsides of Aberhafesp Community, while the flat river valley floor bound on two sides by steep hillsides, and the A489 and B4568 roads stretches out in a westerly direction to Y Drenewydd – or Newtown, as it is known by its English name.

Y DRENEWYDD (NEWTOWN)

Newtown is the largest town in Powys, formerly in the county of Montgomeryshire it was (despite its name) founded as long ago as the thirteenth century as a market town and fording point on the Severn. The wide high street aptly named Broad Street is a reminder of the cattle and livestock markets that were held there until the advent of the motorcar in the twentieth century. The stone bridge at Newtown was yet another bridge designed by Thomas Pensen dating from around 1826; it was soon found to be too narrow, and was widened in 1857 with the addition of cast-iron arches and cast-iron walkways on both sides of the central roadway. The carriageway and the walkways have subsequently been resurfaced to allow for modern day traffic.

Newtown today is known as the birthplace of social reformer Robert Owen (1771–1858) an advocate and forerunner of socialism, philanthropy and the cooperative movement. Another one of Newtown sons was Sir Pryce Pryce-Jones (1834–1920), who developed his drapery business just off Broad Street into one of the world's first mail order enterprises. From his warehouses in the town and using the railways, Welsh flannel goods were exported all over the world. Pryce-Jones' large Royal Welsh Warehouse is easily seen amid the surrounding buildings, from the Severn Way path on the hillside at Penyglodfa to the north of the town. In a little under 13 miles and a drop of less than a 100 feet beyond Newtown, the Afon Hafren reaches its next large Welsh town Y Trallwng, otherwise known as Welshpool.

Although it is possible to follow the Afon Hafren fairly closely for part of its course to Welshpool, the easier and more preferable way is to resume walking along the well-signposted Severn Way, which diverts from the river and takes the semi-derelict Montgomery Arm of the Shropshire Union Canal.

The canal follows a parallel north-easterly route with the Afon Hafren, passing through the village of Llanllwchaiarn and the small settlements at Aberbechan and Abermule. Abermule can be visited by crossing the canal and river on Brynderwen Bridge (1852), yet another of Penson's bridges, located beyond the village on the B4386 road. The bridge is of similar construction to Penson's bridge at Llandinam. As the two previous settlement's names suggest by beginning with Aber, both are confluences of tributaries with the Hafren, Aberbechan with Bechan

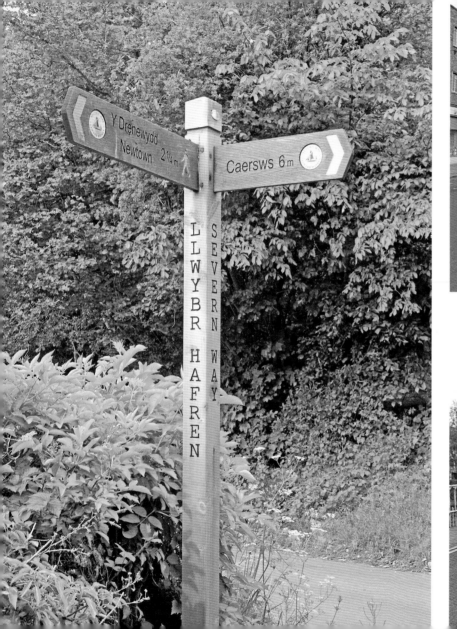

Brook, and Abermule with the River Mule (or Afon Miwl in Welsh). The Montgomery Canal turns onto a more northerly course at Garthmyl towards the village of Berriew (Aberriw) and the confluence with the Afon Rhiw.

Y TRALLWNG (WELSHPOOL) AND THE MONTGOMERY CANAL

The village of Berriew (Aberriw) has some pleasant timber-framed cottages and welcoming hostelries. The Lion Hotel is located near the village church, dedicated to St Bueno, at the centre of the village. The Talbot Hotel and Restaurant is beside the Afon Rhiw Bridge, both are welcome stopping-off points along the Montgomery Canal and the Severn Way. The Montgomery Canal and the Severn Way cross the Afon Rhiw on an aqueduct south-east of the village, near Glansevern Hall and gardens off the A583 Welshpool

Opposite left: One of many Severn Way marker posts that guide walkers along paths that diverge from the bank of the Severn and on occasion mark the path that returns to the river.

Opposite top right: Newtown's broad High Street, witness to the open-air cattle market and fairs before the advent of the motor car...

Opposite below right: Newtown's narrow road bridge across the Afon Hafren, showing the additional cast-iron walkways added to the sides of the stone bridge to give more space to pedestrians; the ironwork was slippery when first constructed in Victorian times, it is now covered over with tarmac and the hazard has been eliminated.

road. On leaving the village on foot it is possible to follow the northern bank of the Afon Rhiw to the bank of the Afon Hafren above Dol-las, the footpath then heads northward through Dyffryn to Wernllwyd. After cautiously following a short length of verge alongside the busy A483, another path is met which returns to the Afon Hafren and crosses the A490 at Cilcewydd; following and then crossing the railway half-a-mile to the north it diverges from the meandering Afon Hafren for a further 1½ miles into Welshpool. Alternatively, the canal towpath takes a more direct 5-mile route from Berriew directly into Welshpool, with an opportunity to take a 1-mile diversion to visit the National Trust Powis Castle (Castell Coch) before reaching the town.

The town centre of Welshpool (Y Trallwng) lies on the eastern slopes of the Severn Valley 70 feet above the Afon Hafren astride of Nant-y-caws Brook (Lledan Brook), and surrounded by a range of hills varying from a couple of hundred feet to over 600 in height. Y Trallwng means marshy ground and the town was originally known as Pool, though prefixed by the word 'Welsh' to distinguish it from Poole in England. This area of the Severn Valley is steeped in history ranging from prehistoric times, to the Roman and Norman conquests. There is plenty evidence of Neolithic habitation across the fertile flood plain and valley at Welshpool, especially at the sites of standing stones, burial mounds and hill forts. A Roman road and Offa's Dyke cross the slopes

of Long Mountain to the south-east of the town, and Beacon Ring Hill Fort tops its summit. Welshpool's borough charter dates from the 1240s, although Domen Gastell, the motte-and-bailey beside the railway station, is thought to have existed since 1196, indeed it was probably the Norman baronial castle that the town developed around. Undoubtedly, Welshpool's most impressive historic building is Powis Castle, less than a mile south-east of the town centre. Powis was home to the Herbert family and the First Lord of Powis (son of Clive of India) after his marriage to Lady Henrietta Herbert. The National Trust looks after Powis, and there are commanding views of a large expanse of the Severn Valley from the castle's impressive garden terraces. Looking eastwards are Long Mountain, Moel y Golfa and the Breidden Hills.

From the Middle Ages Welshpool developed as a market town and centre for the woollen industry; from the eighteenth century it was Welsh flannel, first exported by river, canal and then the railways. The Montgomery Canal stretches 33 miles from Frankton Junction on the Llangollen Canal to its terminus beside the Severn at Newtown, and passes through Llanymynech and Welspool. The canal was abandoned in 1944 and is presently under restoration. The canal connects with the national canal network at Francton Junction in Shropshire and the present limit of navigation is 7 miles to Maesbury Marsh. The navigable section at Welshpool is between Arddleen and Berriew and the Shropshire Union Canal Society is slowly restoring much of the canal to navigation. The canal was built primarily for the transport of agricultural produce and goods, today it is part of the Severn Way and serves as a useful alternative route to the more arduous and unconnected footpaths that run alongside the Severn. The Oswestry & Newtown railway arrived in mid-Wales in 1860 and considerably influenced the development of the Welsh-flannel exports from towns on the Severn, although Welshpool was significantly less industrialised than Newtown. However, the Cambrian Railways did not benefit the outlying farming communities and the transport of goods and produce was still on horseback and carts. The farming community in the Banwy Valley found it especially difficult to transport produce and goods, and at the turn of the twentieth century a 2-foot-6-inch narrow-gauge railway was built between Llanfair Caereinion and the transfer sidings on the Cambrian Railways at Welshpool to alleviate the difficulty. Part of the Welshpool & Llanfair Railway ran through the town along Brook Street, crossing the road at Church Street. The line closed in 1956 as road transport in the area improved; fortunately the line has now been restored for practically its whole length – apart from the town section – through the efforts of railway preservationists. The preserved railway terminus at Welshpool is at Ravan Square at the top of the town.

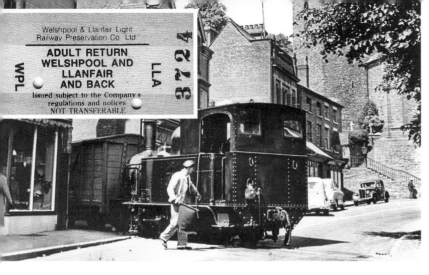

Above: The Welshpool & Llanfair Railway was unusual in that it crossed through the centre of Welshpool to reach its terminus and transfer sidings with the British Railways Cambrian main line and the Severn. The ticket dates from the preservation era when the line was saved as a heritage steam railway.

Right: A commanding view of the Severn Valley above Welshpool, from the terraces of Powis Castle, the town's most famous attraction with strong connections to Clive of India.

THE ENGLISH BRIDGE.

The English Bridge, Shrewsbury.

2

THE MARCHES AND SHREWSBURY

Having flowed through the Marches, the Afon Hafren leaves Wales and crosses the border into England, taking on its English name of the River Severn. The character of the river now changes as it reaches middle age, it now loops and meanders as it flows through a flat and wide flood plain into Shropshire and the county town of Shrewsbury.

In the Middle Ages, the Marches of Wales was the territory between England and Wales governed by the Marcher Lords who were largely independent of the king of England. After the Norman Conquest the Earls of Chester, Hereford and Shrewsbury were entrusted to subdue the Welsh. In the preceding centuries, the Kingdom of Mercia disputed the borderlands and established the garrison towns of Shrewsbury. Ludlow and Hereford, and King Offa established the frontier and boundary with the construction of Offa's Dyke. For centuries, the so-called 'Middle Severn' was navigable, but navigation through the Marches from Welshpool to Bewdley was always a challenge, hampered by insufficient water during droughts or dangerous swells during floods. The Severn Trows and barges were bow-hauled upstream by teams of men, but sometimes assisted by sail, vessels coming downstream drifted with the current, sailed under prevailing wind or pulled along shallows by gangs of bow hauliers.

National Cycle Route 81 between Welshpool, Shrewsbury and Uffington joins the Mercian Way and the Chester and Salisbury National Cycle Route 45 at Upton Magna. Route 45 continues southwards through Atcham, and the Ironbridge Gorge to Bewdley and the Wyre Forest. Both cycle routes follow short sections of the Severn, and visit some of the most popular locations on the river.

BUTTINGTON, POOL QUAY, LLANDRINIO AND THE BREIDDEN HILLS

The Severn Way continues along the Montgomery Canal towpath for a further 3 miles to Pool Quay before reaching

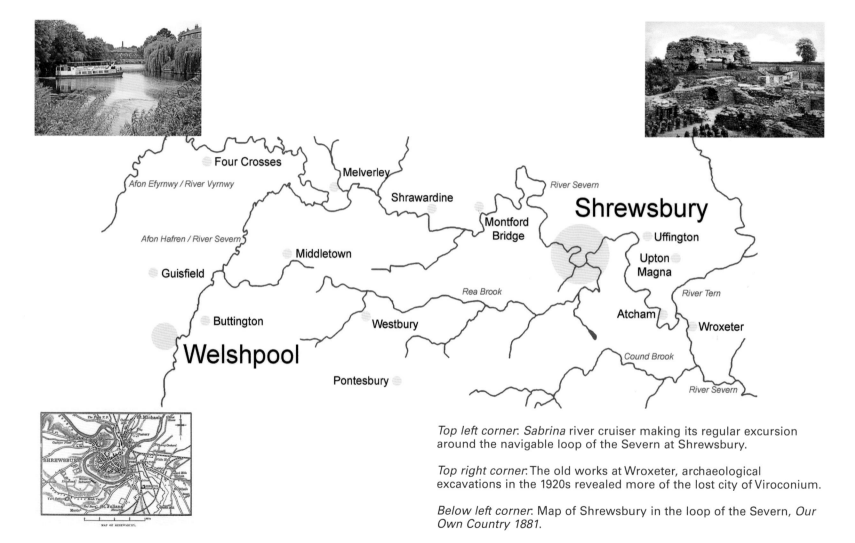

Top left corner: *Sabrina* river cruiser making its regular excursion around the navigable loop of the Severn at Shrewsbury.

Top right corner: The old works at Wroxeter, archaeological excavations in the 1920s revealed more of the lost city of Viroconium.

Below left corner: Map of Shrewsbury in the loop of the Severn, *Our Own Country 1881*.

the Severn. In the nineteenth century, Pool Quay had become the principle transfer point between the Severn Trow traffic and the canal. Today Pool Quay is a favoured spot for those starting a canoe or kayak journey down the Severn. Public right of navigation exists to navigate from Pool Quay to Stourport, beyond it is licensed. Timber was exported downriver especially oak carried on vessels or floated in rafts at least from the thirteenth century and into the eighteenth century. Navigation on the upper Severn above Shrewsbury had become sparse in the eighteenth and nineteenth centuries, and trade consisted of goods such as wine, tobacco and textiles and pottery. The national canal system carried manufactured goods, coal, iron and salt although the downriver trade of timber to the Royal Dock Yards continued from wharfs on the Montgomery canal and the riverbank at Pool Quay for much of the first half of the nineteenth century. Admiral Rodney's pillar was erected in gratitude to the people of Montgomeryshire, for the supply of timber to build ships for the Royal Navy during the Napoleonic wars. The Admiral Rodney pub in Criggion Lane is a suitable stop on the journey down the Severn and less of an excursion than Rodney's pillar, which stands 1,150 feet and 1½ miles beyond on Breidden Hill.

The pub is easily reached from the Severn Way at Crewgreen. The Offa's Dyke long distance path joins the Severn Way near the site of the lost Cistercian Strata

Rodney's Pillar on Breidden Hill.

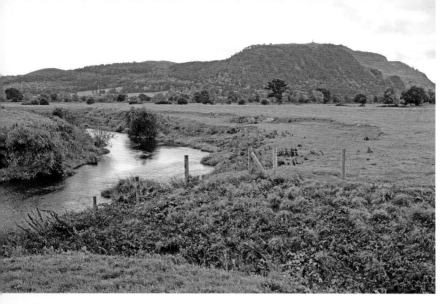

Marcella Abbey; both long-distance ways share the same path alongside the Severn for 5 miles before parting ways a mile south of Llandrinio. Offa's Dyke was built around 785 on the instruction of King Offa, the Saxon king of Mercia. The earthwork served as a boundary between the Saxon Kingdom of Mercia and the Welsh kingdom of Powys.

MELVERLEY, SHRAWARDINE AND MONTFORD BRIDGE

The River Vyrnwy joins the Severn at Melverley, as the Severn Way diverts northward crossing the Severn on the former railway bridge of the Potteries, Shrewsbury & North Wales branch line from Kinnerley Junction, on the Shropshire & Montgomeryshire Light Railway affectionately called the 'Potts'. The old railway connected Shrewsbury and Llanymynech and closed to passengers in 1933, although the line survived to 1960 as a supply route

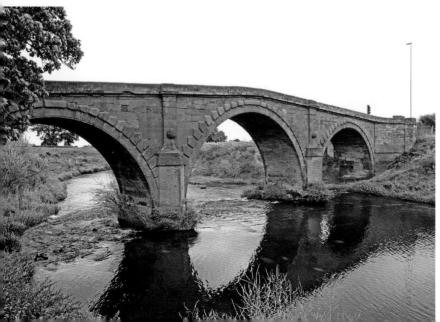

Above: The Breidden Hills from the Severn Way and Offa's Dyke beside the Severn.

Below: The eighteenth-century Llandrinio Bridge takes the B4393 across the Severn. It was closed for a time in December 2015 after flooding caused structural damage, it reopened after weight restrictions were imposed. Regular flooding of the Severn has necessitated extra vigilance and special attention to all the Severn's bridges in recent years, especially bridges built in previous centuries.

Above: The Severn, taken at Edgerly from the Severn Way facing east.

Above right: ...and west, seen from the same spot.

Right: The Royal Hill pub, a true riverside pub and campsite.

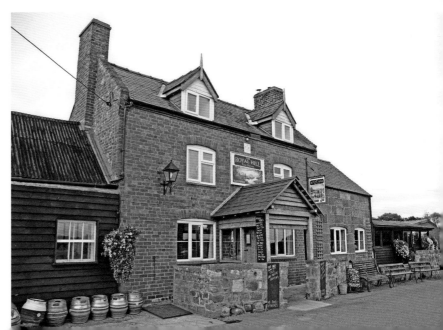

to an ammunition depot. Taking a narrow country road the Severn Way passes through Ponthen and Pentre and crosses the course of the lifted S&MLt railway to turn southward through Shrawardine where it once more meets up with the Severn which has meandered over a more direct route from Crewgreen. The erosion and flooding of this part of the river has moulded the river landscape into a flood plain, scouring out and depositing sand and gravel into each turn of the riverbank. The old red sandstone Montford Bridge was designed by Thomas Telford and built in 1792 by John Carline and John Tilley, it carried the former Holyhead Road the B4380 across the Severn. The new route of the A5 and bridge crossing just south of the village now bypasses the village.

SHREWSBURY

The Severn has some interesting islands on its course between the confluences of the River Vyrnwy right down to the reach above Stourport-on-Severn, where the river is canalised. Some of these islands may well be natural but others are probably the remains of fish weirs and traps, the bylets were probably 'barge gutters' to aid navigation over shallows and weirs or a channel to bypass a fish-trap structure built in the river. The island at Montford and the weir, Bromleys Forge, the Bylet at Fitz, Undercale Shrewsbury, Pimley Manor at Uffington, Atcham, Wroxeter, Eytonrock, Coundlane to name a few, and others beyond the Ironbridge Gorge. The rich and varied riverscape above Shrewsbury is largely isolated and unpopulated with few paths and public rights of way and the river can only be seen at best and explored from a canoe. The Severn Way therefore diverts eastwards from the meandering river at Montford Bridge passing Bicton it rejoins the Severn at Shelton and then passes through the Shrewsbury districts of Frankwell and Mountfields before reaching the Frankwell box girder footbridge and the Welsh Bridge in the town.

The market town of Shrewsbury has a wealth of history, and it was known by many names over the centuries: Pengwern; by its Saxon name, Scrobbesbyrig; in Welsh, Amwythig; and Schrosberie. The town is Medieval in origin and the castle dates back to 1074 and the former Benedictine St Peter and St Paul Abbey to 1083 – the abbey church still survives – in the sixteenth and seventeenth centuries the town developed as a commercial centre for the Welsh wool trade. Shrewsbury Castle stands at an isthmus formed by the loop of the Severn and houses the Shropshire Regimental Museum. In 1070, Roger de Montgomery established a motte-and-bailey on the site, which was rebuilt in stone during the twelfth and thirteenth centuries. The castle was derelict after the English Civil War, but was rebuilt by Thomas Telford in the 1780s on behalf of Sir William Pulteney MP. Telford also built Laura's Tower above the walls of Shrewsbury Castle,

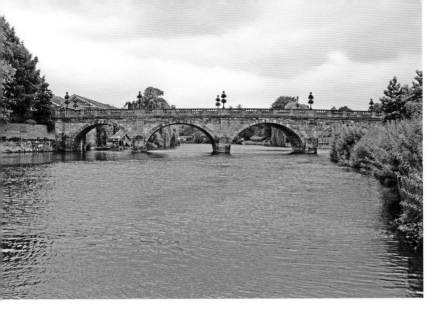

Above: The original Shrewsbury Welsh Bridge was designed by John Gwynn and widened in the 1920s to accommodate the motor car.

Right: The riverscape at Shrewsbury, showing Shrewsbury School and a glimpse of Pengwern Boat house built in 1881, Pengwern Boat Club dates back to 1871, and organises the annual Shrewsbury Regatta.

which offers a panoramic view of the Severn. An equally impressive view of the Severn is from Shrewsbury School in the district of Kingsland, which stands overlooking the river and Pengwern Boathouse – named after the capital of the Saxon Kingdom Llys Pengwern. The school also looks down on its own boathouse, and the site of the former School Ferry, abandoned in the early twentieth century. There are also a number of prominent church spires that rise above the town, all are visible at various points on the river: St Mary's, St Alkmund's and the tower of St Julian's churches.

Shrewsbury has two principle bridges, both are crossings on the former London-Holyhead road, the A5. The first of the two London-Holyhead road bridges over the Severn is the Welsh Bridge designed and built by John Carline and John Tilley in 1795 it has a 5-arch span of 250 feet and stands beside Victoria Quay and Mardol Quay part of the town's old river port. A little further downriver is the Boat House Inn and seventeenth-century plague hospital, and the location of a defunct rope-worked ferry that operated between the Quarry Park and Beck's Field at Porthill. The ferry was replaced with the Port Hill footbridge in 1922, one of three suspension bridges on the Severn built by David Rowell & Co. Westminster two have survived to this day. The next bridge along the Severn is a toll bridge constructed in 1882. The wrought iron and mild steel Kingsland Bridge was built by Cleveland Bridge & Engineering Co. Darlington and has an arch span of 212 feet. The riverside promenade between Port Hill footbridge and the weir at Castle Fields is used as a traffic-free cycle way, a small part of the 14-mile National Cycle Route 81 between Shrewsbury and Wellington. The Quarry Park beside the river and the Dingle are the location for the annual Shrewsbury Flower Show. Another footbridge is the Greyfriars Footbridge, which was erected to elevate pedestrian traffic over the English Bridge. Rea Brook enters the Severn just before the second principle crossing of the London-Holyhead road over the Severn at the English Bridge designed by John Gwyn 1768. The carriageway of the bridge was widened and the original steep incline was reduced in 1921 to aid traffic. On the abbey side of the bridge is the Congregational chapel, opened in 1864 and now part of the United Reformed Church. The former turnpike London-Holyhead road left the town passing Shrewsbury Abbey and the remains of the Montgomeryshire Light Railway terminus, which once occupied the car park at the site of the pulpit in Forgate Street. Today both the Welsh and English bridges serve Shrewsbury as the principle road crossings into the town. One final crossing before leaving the town was at Castle Footbridge designed and built by David Rowell & Co. est. 1855 the company specialised in the manufacture of wire rope, metal fencing, prefabricated metal buildings and metal suspension bridges, the company closed in 1970. The bridge was replaced in 1951 by a pre-stressed concrete, post-tensioned cantilever suspension bridge. Two of David Rowell & Co. bridges over the Severn still

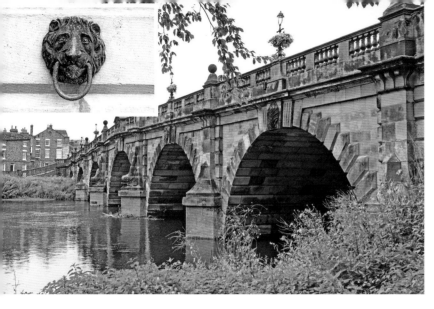
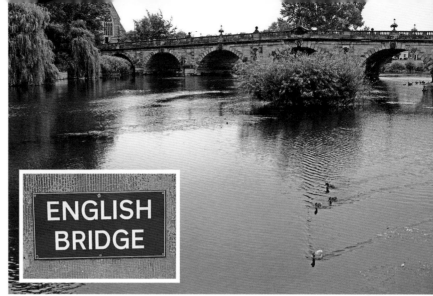

Above: The English Bridge from the west bank of the Severn beside the confluence of Rea Brook. In the abutments of the bridge are ornamental features – lions with mooring-rope eyes.

Above right: Downriver from the English Bridge from the west bank, the natural sand bars are formed by the deposits of mud from of Rea Brook.

Right: Kingsland Toll Bridge 1883, designed by John William Grover.

survive the Port Hill footbridge mentioned earlier and one at Apley estate above Bridgnorth.

The Severn Way closely follows the river through the districts of Ditherington and Monkmoor crossing over the A5112 and then under a series of modern road bridges taking the A49 and A5 roads over the Severn, and also passes under the Shrewsbury & Birmingham railway bridge. Ditherington is the start of the Shropshire Way, which passes through Uffington on the opposite bank of the Severn tracing the course of the disused Shrewsbury canal for a short distance as it leaves the town. The Shropshire Way then heads northward past Haughmond Hill and the remains of Haugmond Abbey, while the river Severn and the Severn Way continue onto Atcham. Some more out-of-water lengths of the Shrewsbury canal can be traced alongside the northern edge of Attingham Park to Berwick Wharf on leaving Upton Magna on Cycle Route 45. As river transport finally declined in the upper reaches of the Severn above Shrewsbury the canals, roads and railways remained and developed as the principle lines of communication and commerce. The Shrewsbury canal was part of the Shropshire Union Railways & Canal, owned by the London North Western Railway. This combination of canal and railway offered a far more expedient and cheaper mode of transport to the river. Even for the transport of bulk goods, such as coal and grain the ease, speed and cost of the alternatives eventually put pay to the last vestiges of the Severn River trade. Today the canals are virtually non-existent in the upper reaches of the Severn Valley, and the railways that followed closely the course of the river have largely disappeared themselves, losing out to roads as the main arteries of communication, and transfer of goods along the Severn.

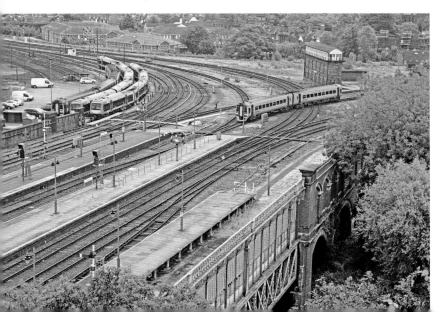

Shrewsbury railway station was built in 1848, and part of the station extends over the Severn. Arriva Train Wales operate the station and one of their trains is seen approaching from the mid-Wales line. The company was once operated jointly by the GWR and LNWR, before the grouping of the railways in 1921 and nationalisation under British Railways 1947.

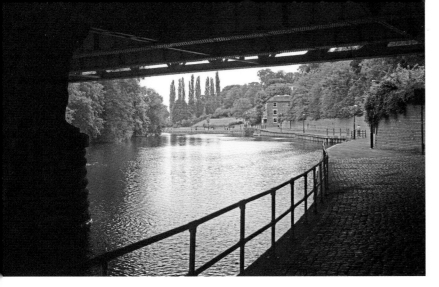

Above: Beneath the Railway Bridge the Severn, and the long distance cycle track NCN route 81, from Shropshire to Wales.

Right: Laura's Tower built by Thomas Telford with commanding views of the Severn.

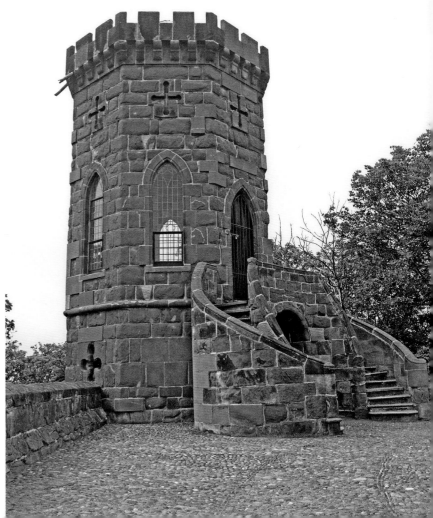

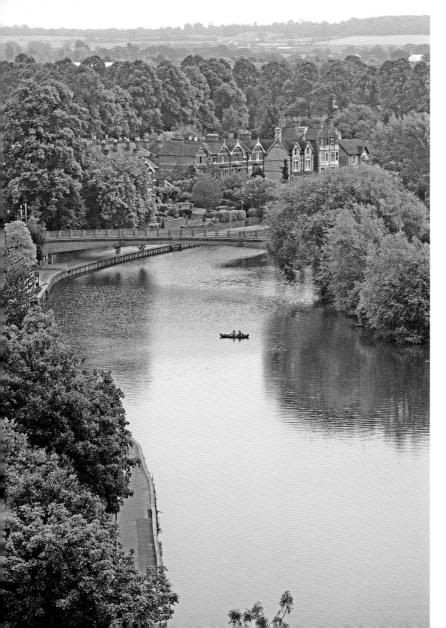

ATCHAM AND ATTINGHAM PARK

There are two bridges over the Severn at Atcham, John Gwynn designed the older Atcham Bridge in 1776. The design was similar to Gwynn's original English Bridge at Shrewsbury with a similar 400-foot span and seven arches, before the English Bridge was widened and flattened-out in 1921. A new open-spandrel reinforced-concrete arched bridge was built for Shropshire County Council during 1927–29. Built by Grays Ferro Concrete Co. and designed by L. G. Mouchel. St Eata's Church Atcham overlooks the bridges and the Severn, founded in Saxon times none of the earlier church survives, although stone from the abandoned Roman city of Viroconium (Wroxeter) was used in the present structure, the tower is twelfth century, the belfry fifteenth century and the chancel is thirteenth century.

The Mytton & Mermaid Hotel in the village is a Grade-II listed eighteenth-century coaching inn overlooking the Severn, and stands opposite the entrance to Attingham Park. Part of its name comes from Mad Jack Mytton; John Mytton was a Regency rake and eccentric who squandered his inheritance on drinking, hunting and gambling. Attingham Park includes 250 acres of deer park laid out by

The view from Laura's Tower and the view of the 1950s Castle Bridge that replaced a former chain suspension bridge similar to the one at Porthill.

Above: Dawn at Attingham Park and the morning light over the deer park and the Severn's tributary the River Tern.

Inset: The gates and driveway to the house and grounds are in the village of Atcham directly opposite to The Mytton & Mermaid Hotel.

Right: The Severn in flood at Atcham beside the grounds of The Mytton & Mermaid Hotel, a former coaching inn with strong connections with the well-known eccentric and Regency rake Jack Mytton.

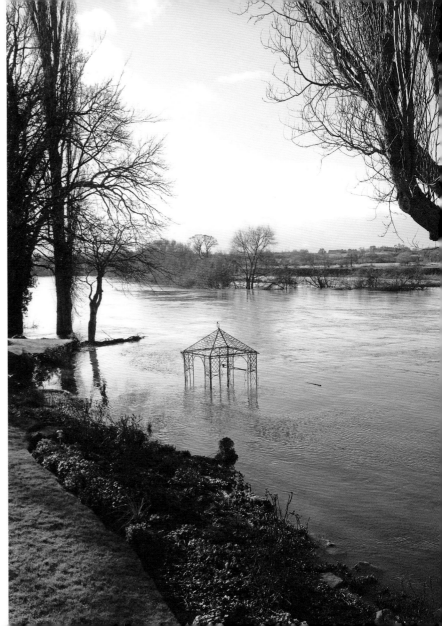

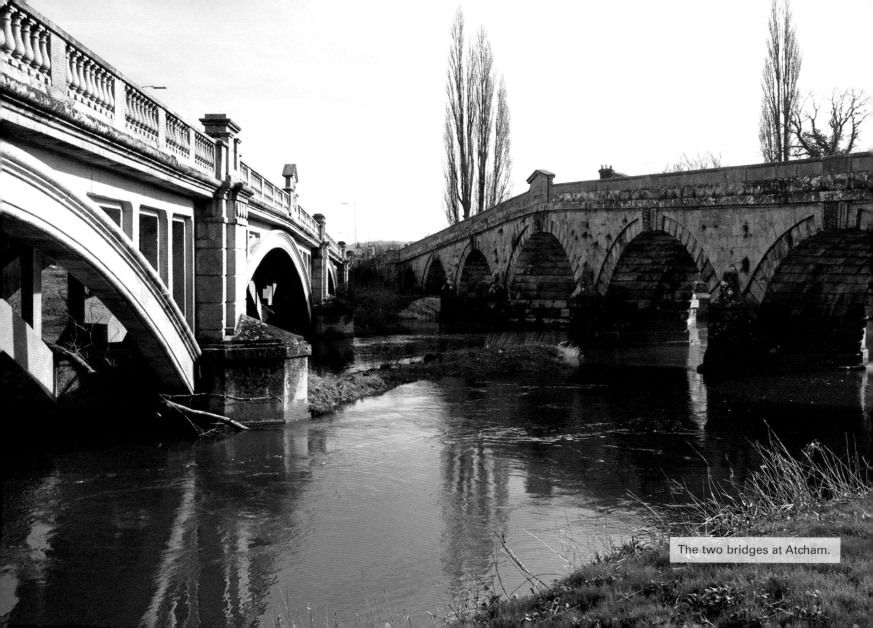

The two bridges at Atcham.

Humphrey Repton beside the River Tern. George Steuart designed the neoclassical house for the First Lord Berwick in the late eighteenth century. The house belongs to the National Trust and is open to the public for most of the year. The River Tern joins the Severn shortly after passing under the B4380 road bridge.

WROXETER AND EYTON ON SEVERN

The Severn Way and the river once more part company. The Severn Way takes the B4380 for a little over a mile before turning south onto a country lane through Wroxeter and Eyton-on-Severn to arrive at Lower Dryton farm. At the farm, the Severn Way takes a farm track alongside an abandoned racecourse to meet up once more with the Severn and the B4380 outside Cressage. Although the Severn is never far away, the 5-mile route offers few opportunities to view the river since there are only two footpaths that meet the river and each is on opposite banks of the river.

A short way from the Severn Way at Wroxeter are the remains of Roman Viroconium, the fourth largest city in

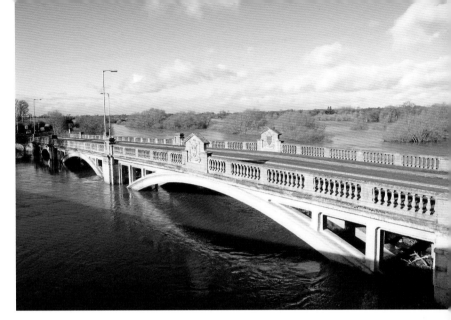

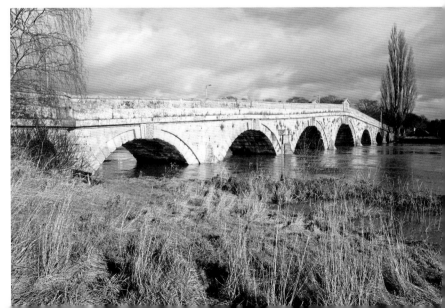

Above: The New Atcham Bridge designed by L. G. Mouchel and built in 1929.

Below: The Old Atcham Bridge designed by John Gwynn and built in 1776.

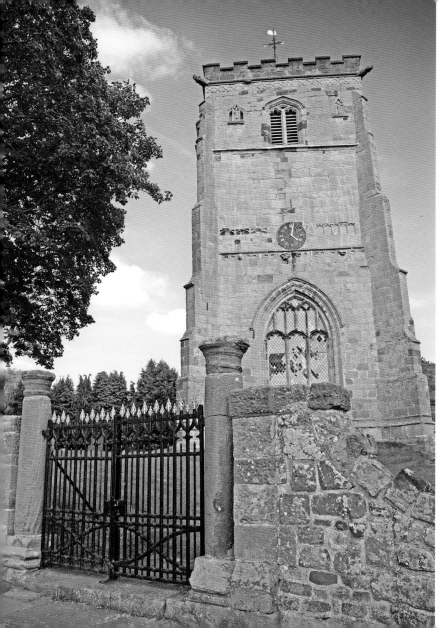

Roman-occupied Britain, abandoned by the end of fifth century. The Romano-British inhabitants of the city called the Severn 'Sabrina', and the Roman Watling Street passed through the town to cross the river at Wroxeter. In the 1920s excavations uncovered baths and the bases of a row of columns from the forum on the opposite sides of the lane the former course of Watling Street. In the nearby village of Wroxeter the gates of St Andrew's Church, founded in Anglo-Saxon times, is partially constructed from reclaimed stone from abandoned buildings of the Roman city. The earliest parts of the present church date from the eighth and ninth centuries and among the most noticeable Roman stonework are the supporting pillars of the front gates leading to the churchyard from the lane.

Parts of St Andrew's Wroxeter parish church are built from stone reclaimed from the nearby Viroconium Roman City.

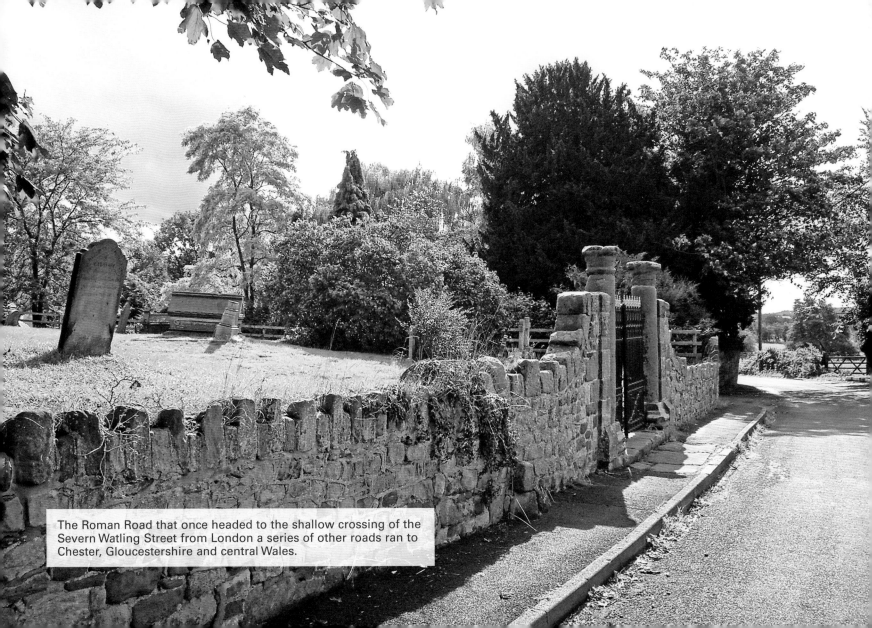

The Roman Road that once headed to the shallow crossing of the Severn Watling Street from London a series of other roads ran to Chester, Gloucestershire and central Wales.

3

CRESSAGE TO THE IRONBRIDGE GORGE

The Industrial Revolution had its roots in the mineral-rich Severn Gorge and the adjoining valleys of Coalbrookdale and Madley. The raw materials of coal, iron ore, limestone and clay, for porcelain were easily mined in the gorge, and the Severn allowed for easy transport of manufactured goods. In 1709 in the Coalbrookdale valley the Quaker Abraham Darby I developed a method for smelting iron using coke, which began the great eighteenth-century iron industry and subsequent Industrial Revolution. The remains of Bedlam Furnaces built in 1757 stand beside the river, and the famous Iron Bridge erected in 1779 by Abraham Darby III crosses over the Severn Gorge both witness to the new industrial age. The Iron Bridge in the Severn Gorge immediately became a new wonder of the world, the town that grew up around the bridge took the name Ironbridge, and the Severn Gorge came to be known as the Iron Bridge Gorge. Of immense historical importance, the Gorge is now a UNESCO World Heritage site. The industrial heritage of the Iron Bridge Gorge is further preserved in the Bliss Hill open-air museum, which lies in the adjoining Hay Brook Valley, and incorporates the former Blists Hill blast furnaces, brick and tile works. The remains of the steep Hay Inclined Plane connects the Shropshire Canal to the Coalport Canal, which ran alongside the Severn. Coal mining, clay production, and the manufacture of decorative tiles was established on the south bank of the river at Jackfield.

CRESSAGE AND BUILDWAS

The Severn Way crosses the Severn at Cressage, a local path heads northeast for a mile to the village of Leighton on the north bank of the Severn. There are a number of laybys on the B4380 above Leighton to park and view the meandering river as it heads off to Buildwas. The Kynnersley Arms in the village is worth the diversion from

CRESSAGE TO THE IRONBRIDGE GORGE

The Severn at the Ironbridge Gorge; *Left*: the cross at Cressage. *Right*: the iconic Iron Bridge.

the Severn as the building has a cellar that houses the blowing arch of a seventeenth-century blast furnace and a water wheel.

Returning to Cressage the familiar yet distant landmark of the 1,335 feet (407 metres) Wrekin and its Iron Age fort rises above the otherwise flat Shropshire plain. A five-span timber trestle bridge on four stone abutments, and a tollhouse at the north bank was once the toll bridge crossing point of the Severn at Cressage. The county council took over the structure when it became unsafe, and replaced it with the present three-span reinforced-concrete arch bridge designed by L. G. Mouchel. From Cressage the Severn Way makes its way through the village of Sheinton. When the the Iron Bridge opened in 1780, it opened a Bridgnorth-Shrewsbury coach route that passed through Broseley instead of nearby Much Wenlock. In 1779 the Much Wenlock turnpike trustees, turnpiked the lane from the Buildwas bridge road at Gleedon hill through Sheinton to the Much Wenlock-Shrewsbury road at Cressage; thus avoiding Harley Hill and Wenlock Edge but without diverting Shrewsbury traffic from Much Wenlock.

The Severn Way leaves this former turnpike road at Buildwas Park and turns into woodland to follow the track bed of the old Severn Valley Railway line to

The Severn in flood at Cressage from that B4380 bridge that crosses the Severn north of the village, a hardy fisherman is sat on a spit of land between the river and its flooded plain.

CRESSAGE TO THE IRONBRIDGE GORGE 47

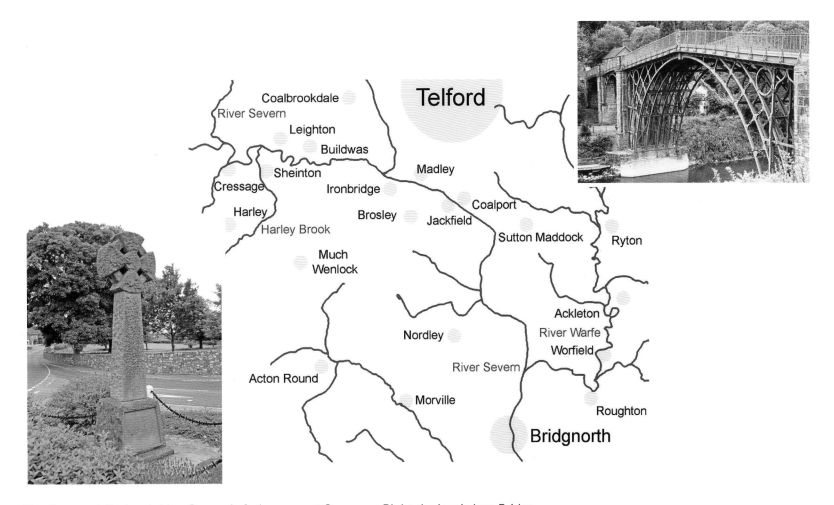

The Severn at the Ironbridge Gorge; *Left*: the cross at Cressage. *Right*: the iconic Iron Bridge.

the Severn as the building has a cellar that houses the blowing arch of a seventeenth-century blast furnace and a water wheel.

Returning to Cressage the familiar yet distant landmark of the 1,335 feet (407 metres) Wrekin and its Iron Age fort rises above the otherwise flat Shropshire plain. A five-span timber trestle bridge on four stone abutments, and a tollhouse at the north bank was once the toll bridge crossing point of the Severn at Cressage. The county council took over the structure when it became unsafe, and replaced it with the present three-span reinforced-concrete arch bridge designed by L. G. Mouchel. From Cressage the Severn Way makes its way through the village of Sheinton. When the the Iron Bridge opened in 1780, it opened a Bridgnorth-Shrewsbury coach route that passed through Broseley instead of nearby Much Wenlock. In 1779 the Much Wenlock turnpike trustees, turnpiked the lane from the Buildwas bridge road at Gleedon hill through Sheinton to the Much Wenlock-Shrewsbury road at Cressage; thus avoiding Harley Hill and Wenlock Edge but without diverting Shrewsbury traffic from Much Wenlock.

The Severn Way leaves this former turnpike road at Buildwas Park and turns into woodland to follow the track bed of the old Severn Valley Railway line to

The Severn in flood at Cressage from that B4380 bridge that crosses the Severn north of the village, a hardy fisherman is sat on a spit of land between the river and its flooded plain.

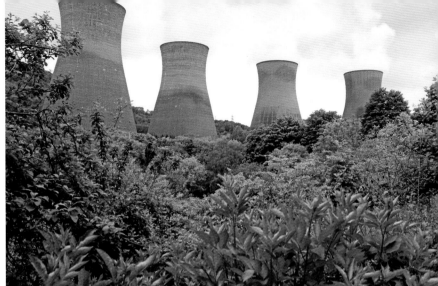

Above: The view of the Severn flood plain at Cressage, and the Wrekin a steep volcanic plug in the distance.

Above right: The cooling towers of Buildwas Power Station.

Right: The Severn valley looking due east along the flooded river towards Buildwas.

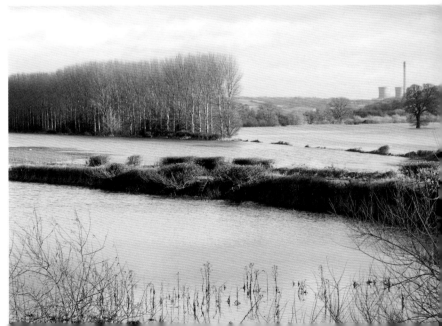

Buildwas Abbey and the Severn at Buildwas Bridge. The present Buildwas Bridge dates from 1992 when it replaced two earlier structures, which were both damaged beyond repair by the movement of the unstable banks of the river. A mile below the bridge is Buildwas power station and the railway bridge that carries coal trains to the station sidings.

John Fowler designed the 150-foot long cast-iron single-arch bridge known as the Albert Edward Railway Bridge, and the sections were cast at the Coalbrookdale company foundry, it has a companion bridge, the Victoria Bridge, that carries the preserved Severn Valley Railway over the Severn at Arley.

COALBROOKDALE

Iron smelting in Coalbrookdale was revolutionised by the iron founder Abraham Derby I using coke, a Coalbrookdale blast furnace is preserved in situ, the valley is also home to one of the Ironbridge Gorge Museums, the Museum of Iron occupies the 1838 Great Warehouse and the Ironbridge institute the Long Warehouse.

A heritage trail includes Coalbrookdale railway station and Great Western Railway Viaduct, Darby Houses, Quaker burial ground and Tea Kettle Row. A horse-drawn plateway from the furnaces in the valley brought iron goods to the neo-Gothic warehouse and wharfage on the Severn, ready for shipment down river by Severn Trow.

IRONBRIDGE

The Severn Way meets the Shropshire Way at the Iron Bridge and both cross the Severn together. The Severn follows the river closely heading east and the Shropshire Way heads west towards the cooling towers of Buildwas power station and up and along the thickly wooded Benthall Edge. In 1777–79 the Coalbrookdale Company, under the direction of Abraham Darby III, cast the

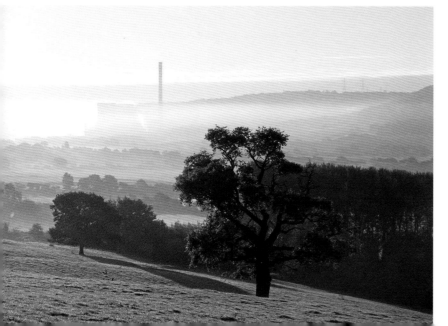

Dawn over Buildwas and the Severn Valley from Leighton bank and the B4380 road.

Above: The Coalbrookdale Company riverside warehouse where Severn Trows once moored to load their cargo of manufactured iron goods for transport downriver.

Right: The river at the confluence of the Coalbrookdale stream.

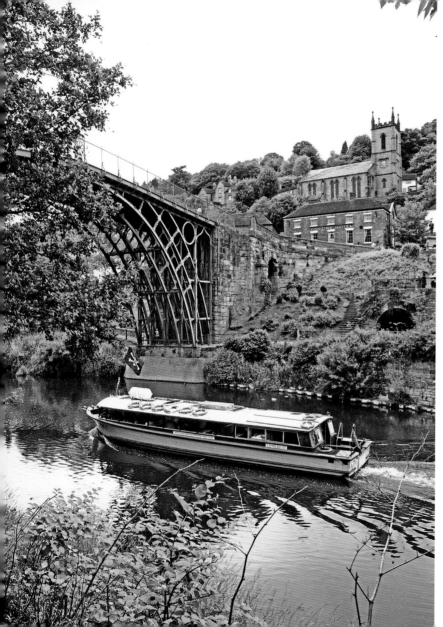

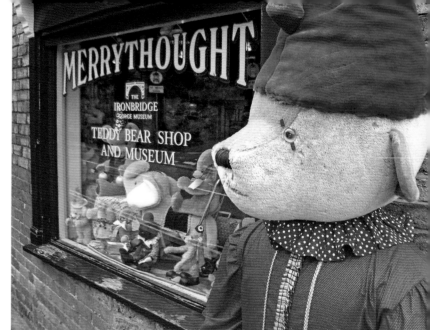

Above: The Merrythought Teddy Bear Shop and Museum, next to the shop is the factory where the soft toys are made beside the Severn.

Left: The Ironbridge Scenic Cruisers boat on the navigable stretch of the river at Ironbridge.

component parts of the Iron Bridge. The bridge is unique in that it is the first single-span iron bridge in the world, with a span of 100 feet and a total length of 196 feet and rise of 50 feet. The Iron Bridge high span allowed lighter tonnage 'upstream' sailing trows unimpeded passage.

The only surviving complete Severn 'downstream' trow *Spry* is now preserved under cover at Bliss Hill museum, it once operated on the tidal Severn below Worcester carrying coal and stone.

The Ironbridge Bridge Co. charged tolls for crossing by the number of animals pulling a vehicle, including tolls for luggage wagons, carriages, and mailcoaches, passengers on horseback and on foot. The bridge closed to vehicles in the 1930s because of distortion caused by the movement of the riverbanks, and extensive repairs were carried out in 1972 and 2000. The navigable stretch of river in the gorge is now isolated and no longer accessible from down river, although Ironbridge Scenic River Cruisers operate the *Hafren*, a pleasure launch, over this length.

The car park beside the Ironbridge was the site of the Ironbridge and Broseley railway station part of the Great Western Severn Valley Railway. The Railway Hotel, which stood over the goods yard and a few metal rails embedded in the road bearing witness to the former existence of a railway. The Severn Way long-distance path from this point onwards seldom parts company with the river and it is possible to follow the Severn for most of its course to its estuary. The Severn Way path now shares with route 45 of

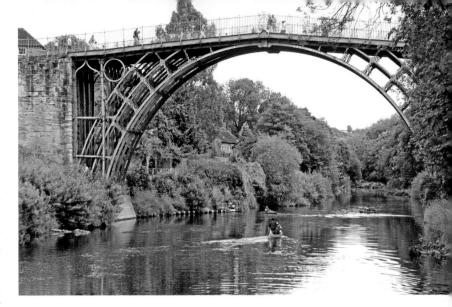

The Ironbridge seen from upstream, cast by Abraham Darby III in 1777–79 the bridge has a total length of 196 feet and a central span of 100 feet, it closed to vehicles in the 1930s because of movement of the banks, but remains open for pedestrians.

the National Cycle Route the old lifted SVR path through the gorge, towards Jackfield, Apley and Bridgnorth.

JACKFIELD

Jackfield lies on the south bank of the Severn and it was once the river port for Brosley and Benthall; its exports were coal and pottery, especially black earthenware mugs and tiles. The peculiar geology of the Severn Valley at Jackfield in

the Ironbridge Gorge resulted in a major landslip in 1952, which devastated a large part of the centre of the village and resulted in many dwellings disappearing into the river, the river itself narrowed by fifteen yards. The unstable and moving ground has resulted in the displacement of roads and the former track bed of the SVR. Stabilisation work started in 2014, drilling and filling mining voids, piling to prevent the movement of sloping ground, the addition of concrete columns, construction of revetments to reduce river erosion, and the drainage of degraded slopes is due to be completed in the summer of 2016.

The so-called 'Free Bridge' at Jackfield was built in 1909 principally to avoid the toll charges on the Coalport Bridge and Iron Bridge. Designed by L. G. Mouchel and built in 1909 in reinforced concrete with a total span of 230 feet, the bridge was demolished when it was found to be badly corroded in its place is the present asymmetric cable-stayed structure. Passing the eighteenth-century riverside Black Swan Inn, the overgrown platform of the SVR Jackfield Halt and railway crossing gates the Severn Way path passes the old Craven Dunhill encaustic works, now the Tile Museum. A little further down the former railway path is the Maws Craft Centre the site of the Maws tile works, in its heyday the largest in the world. The Boat Inn stands a little further along the road, the Inn is the archetypal mughouse, so called because of the earthenware mugs used for serving ale. These mugs were made at Jackfield and traded along the Severn to other riverside inns which inevitable adopted the name 'mughouses' from the inexpensive earthenware serving mugs. A ferry once connected Jackfield and Coalport, though it was replaced in 1922 by the Jackfield Memorial Footbridge which was erected to commemorate the fallen servicemen from both communities in the First World War.

The Coalport Bridge further down river was built in 1810 to replace a wooden structure that was destroyed in floods, the nearby Woodbridge Inn bears the name of the former bridge. The bridge connects Jackfield and Coalport on opposite sides of the river; both were served by railway stations of the same name.

The station south of the river was on the former SVR line and closed in 1963, but the owners of this well-kept station provide self-catering accommodation from two restored carriages in a landscaped railway setting. No trace of the London & North Western Coalport station exists, it was closed in 1952, but the site has a railway bridge and some railway cottages and is the start of the Silkin Way, which passes through Bliss Hill and Madley to Telford town centre.

Opposite top left: The tile works at Jackfield and the nearby Maw & Co. Benthall works now a craft centre, Jackfield was once world famous for the manufacture of encaustic tiles.

Opposite below left: Jackfield rapids and the continuing consolidation work to prevent further slippage of the river banks.

Opposite right: The New Jackfield Bridge was built in 1994 after the old reinforced concrete bridge had decayed and become unsafe.

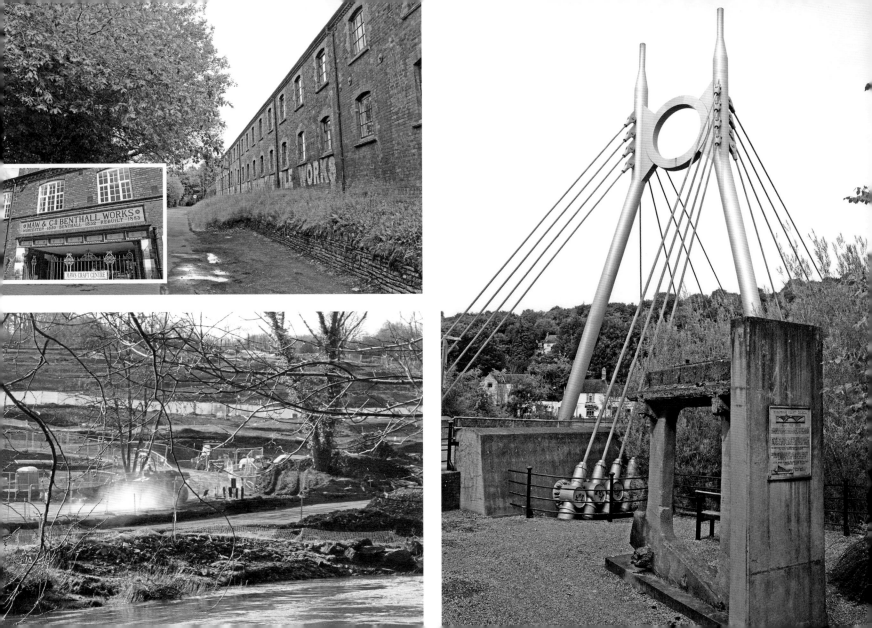

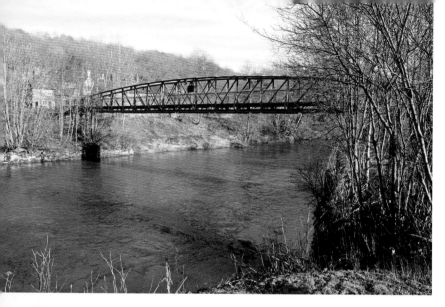

COALPORT

Coalport was once a large river port, practically a small town it developed around the interchange of the Shropshire Canal and the River Severn. The upper portion of the canal at Bliss Hill was connected to the lower canal by the Hay Farm inclined plane; 20-foot canal tub boats were lowered and lifted by the action of gravity on special cradles running on rails. The rails sank into the canal at each end of the incline and the tub would float off as the cradle submerged with the sunken rails.

Part and the abandoned river sections of canal are out-of-water but can be easily traced across the riverbank but much of the wharfage has disappeared. The most significant warehouses are at the Coalport Porcelain works, which also has a preserved bottle kiln. The works were famous for fine white porcelain especially Empire Style and Jewelled Ware. The Severn can be followed on both banks for half-a-mile in each direction, from the bottom of the Hay Incline, the Tar Tunnel and Shakespeare Inn on the Coalport side to The Brewery Inn. Then by crossing the Coalport Bridge to the Woodbridge Inn and Severn

Above: Jackfield and Coalport Memorial Footbridge opened in 1922; it was paid for by public subscription, and commemorates the servicemen lost from Jackfield and Coalport during the First World War.

Below: The foot of the Hay inclined plane, the Tar Tunnel and part of the Shropshire Canal at Coalport.

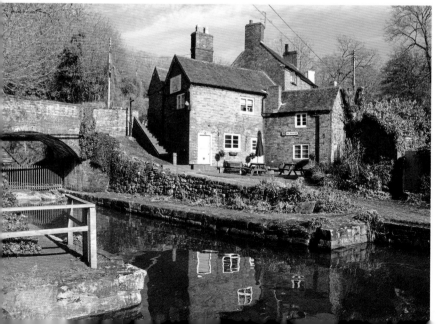

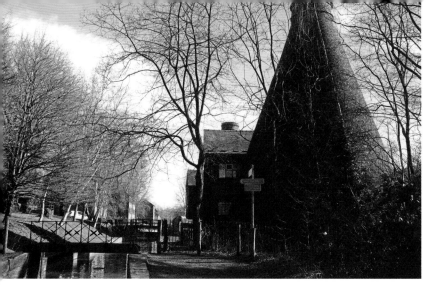

Above: Coalport China Works bottle kiln, Coalport is one of the Museums of the Gorge. The museum holds the national collection of Coalport and Caughley china.

Right: Coalport Bridge and the Woodridge Inn which takes its name from the former wooden bridge that once stood on the same site.

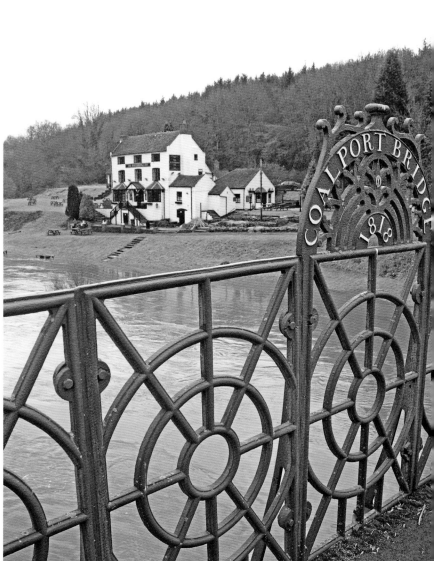

Valley Way on the Jackfield side of the river, to follow the further half-mile to the Boat Inn and the Memorial Bridge, and return to the start on the Shropshire canal below the inclined plane.

APLEY FORGE

On leaving the Ironbridge Gorge, the Severn flows for some 3 miles through particularly picturesque woodland and riverscape to Apley Forge. Linley station on the lifted SVR still stands above Apley Forge, the station served Appley Park across the Severn, and the isolated communities of Linley Brook, Linley and Nordley, that had no road access to the station and could only be reached on foot over fields.

The Georgian Apley Hall on the east bank of the Severn was built in 1811 for Thomas Wyatt MP for Bridgnorth and High Sheriff of Shropshire. The house once belonged to the Foster Family from 1867 to 1960. Between 1962 and 1987, it was a private school. The house was sold in 1997 when the school closed and converted into self-contained luxury apartments in 2004. Apley Park Suspension Bridge, or Linley Bridge was built by David Rowell & Co. of Westminster, London in 1905, and is similar in appearance to the one other surviving bridge Porthill Bridge at Shrewsbury.

The river flows southwards from Apley Forge for 3½ miles to Bridgnorth, which is easily reached on the National Cycle Route 45, and the long-distance Severn Way path, passing in sight of the old water-pumping station at Pendlestone Rock and High Rock on the opposite east bank, before entering onto the riverside golf course at Bridgnorth.

Left: The Severn Valley Way, part of the route of the former Severn Valley Railway now a cycle way.

Opposite left: Apley Park Bridge designed by David Rowell & Co. in 1905.

Opposite right: Apley Hall was built in 1811 for Thomas Whitmore MP for Bridgnorth the Severn Valley Railway across the river had to build a chain bridge to link the property to their station at Linley.

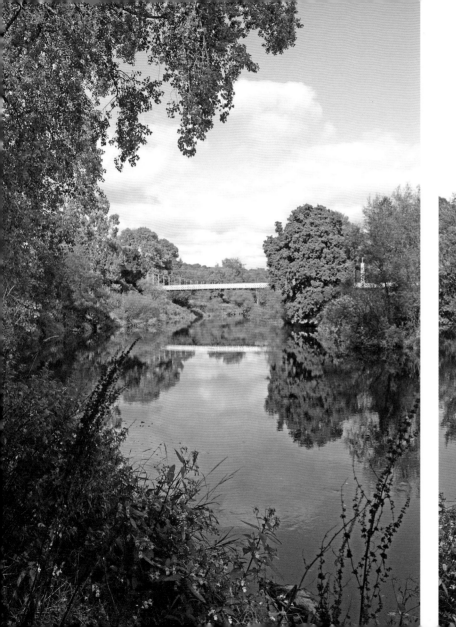

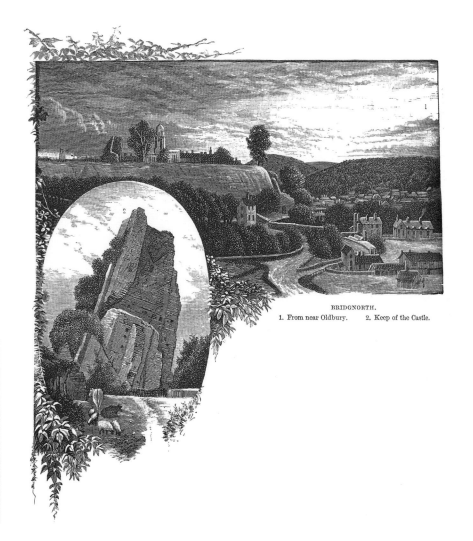

BRIDGNORTH.
1. From near Oldbury. 2. Keep of the Castle.

Lithograph *Bridgnorth, Our Own Country,* 1881 and the keep as it appears today.

4

BRIDGNORTH TO BEWDLEY

As Bridgnorth's name suggests, the town is named after a bridge over the River Severn; a bridge and town that developed north of a former settlement, possibly Quatford. Other names for Bridgnorth were Brigge, Brug and Bruges. The town is divided on two levels: High Town, which hosts the fortifications, churches and market centre areas and Low Town, which is situated alongside the Severn and has the river bridge and was the site of commercial river port.

Earliest records of the town show that the Danes camped at Cwatbridge in AD 895, and a defensive mound to defend against Viking incursions was built by Æthelfleda in AD 912, possibly were the remains of Bridgnorth Castle now stand. After the Norman Conquest, the manor of Bridgnorth was granted to Roger de Montgomery. The town is first referred to in 1101, when Robert of Bellême, Third Earl of Shrewsbury and son of Roger de Montgomery, built a castle and church in High Town as a defence against the Welsh. In the centuries that followed Bridgnorth castle and the town were at the centre of conflict, first besieged by Henry II; the town was burnt in the baronial revolt of the Marcher Lords in 1322, and destroyed by fire again in 1646 by Parliamentarian forces in the Civil War. The Georgian town of Bewdley is 15 miles downriver, and is similar to Bridgnorth in that it was also at one time a busy river port, and remains a crossing point on the Severn, although like Bridgnorth a new road and bridge crossing have bypassed the town. The one-time towpath used by bow-haulers and horses to pull vessels across the shallow bank of the Severn above Bridgnorth ran along the west bank between the two towns, the path remains a pleasant riverside walk and route for the North Worcestershire long-distance path.

BRIDGNORTH A FORMER RIVER PORT

The northern boundary of the town of Bridgnorth follows the course of Cantern Brook, half-a-mile below

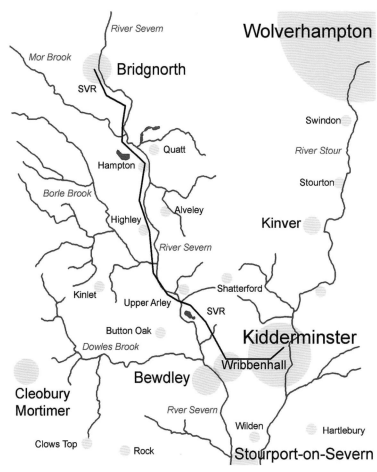

The map of the Severn from Bridgnorth to Bewdley.

Inset: The Severn at Bewdley.

the confluence of the River Worfe and River Severn beside the A442 Bridgnorth Telford road. Bridgnorth was once an important river crossing and inland river port on the Severn. By the early seventeenth century, Low Town had a dockyard and extensive quays with warehouses on both sides of the river. Pack animals were used to carry goods between High Town and the port at Low Town, the remains of a dwelling and stables can be seen in Cartway (so called because carts could be taken up to high town the alternative alleyways being far to narrow), which connects the two levels of the town. Pack animals were used on a number of steep alleyways that passed between High and Low Town. The half-timbered building that stands at the bottom of Cartway and dates from 1580 is a remarkable survivor of the bombardment and subsequent fire which ended the siege by Cromwell's forces in the Civil War.

The building was the former residence of Revd Dr Thomas Percy (1729–1811) Bishop of Dromore. In the late nineteenth and early twentieth centuries the building was used as offices for an iron foundry. In the early years of the nineteenth century, Hazledine's iron foundry stood on the east bank of the Severn, with associations with two famous engineers: John Urpeth Rastrick, a railway engineer and employee of the foundry; and Richard Trevithick, the inventor of the high-pressure steam engine. The first passenger steam engine *Catch Me Who Can*, designed by Trevithick and engineered by Rastrick, was built at the foundry in 1808.

Built in 1824, Southwell's Carpet Factory occupied the site of a former Franciscan friary on the west bank of the Severn; the factory was demolished and redeveloped for housing in the 1980s. Thomas Telford designed Bridgnorth's present 360-foot-span stone arch bridge in 1810; Telford's original design is very much the same today, despite extensive alterations and widening of the carriageway in the 1960s. On the eastern bank of the Severn, a small channel called the Bylet diverges from the main channel of the river to form an island. The Bylet is either the remains of a fish trap or a separate channel for the trow traffic that used the river both upstream and downstream of the bridge. The main quayside ran alongside Underhill Street – the centre of the port of Bridgnorth – crowded

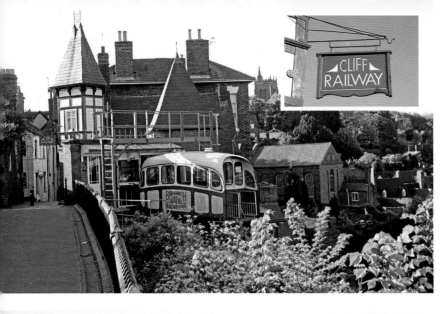

with warehouses, stables, inns, a harbour masters house and a water wheel that once pumped water from the river to High Town.

A number of alleyways rise up from Low Town and connect with the centre that lies in High Street, High Town and the town hall were built after the Civil War in 1652. Granary steps and St Leonard's steps rise up from Friars Street and Cartway, The bank steps from the Riverside, Stoneway steps or the Castle Hill vernacular railway, St Mary's Steps, Library Steps from Underhill Street and Canon Steps from New Road. Ebenezer Steps connect between Railway Street and New Road. The town was also a busy cattle and livestock market, now replaced with a car park and supermarket. The two churches prominent from the riverside are St Mary Magdalene Church, designed by Thomas Telford, and St Leonard's, which is predominately Victorian. The town has retained many of its historic buildings, including seventeenth-century coaching inns, late Georgian houses in East Castle Street, seventeenth-century almshouses, and a Congregational chapel on Stoneway Steps – now used as a theatre.

Above: The upper terminus of the funicular at Castle Walk provides a link between High Town and Low Town.

Below: Bridgnorth and the view from Castle Walk, the view of the Severn as it enters Bridgnorth from the north below Pendlestone and High Rock, immediately below is Bridgnorth Low Town.

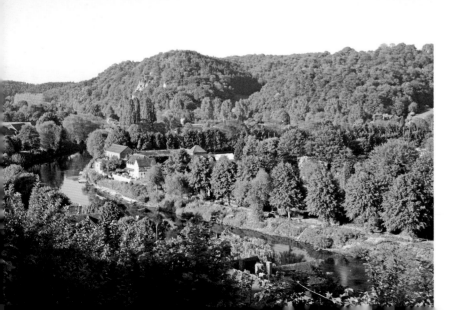

Above: The Severn as it enters Bridgnorth.

Right: The Bylet looking south downriver, the bylet was like many along the Severn a barge gutter used for navigation.

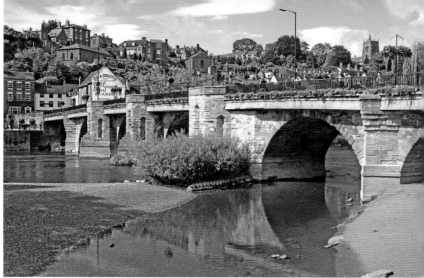

Above: The bridge at Bridgnorth and the bylet, across the bridge is the famous painted sign of 'S. E. & A. Ridley Ltd Seeds' seed merchants, a nearby plaque explains how the building was once a warehouse on the River Severn. Sacks of seeds were hoisted into the warehouse from a small dock.

Left: The Bylet looking north towards Bridgnorth Bridge.

Opposite right: GWR 813 a 0-6-0 saddle tank working a steam crane to lift an antique South Wales Barry Railway (BR) carriage at Hampton Loade Station. Typical of the many jobs carried out by staff and volunteers on the SVR. The tank engine and the B. R. coach 163 like much of the rolling stock on the SVR relies entirely on fund raising and donations from the public to keep them in service on the railway.

Undoubtedly, one of the greatest attractions is the number of pubs and restaurants in the immediate confines of the town. The view of the River Severn from the castle gardens is also particularly impressive with Panpudding Hill and The Severn Valley Railway station to the west, with the Severn and the A458 Bridge at Oldbury to the south. Looking northwards from Castle Walk, the view is of the course of the Severn as it flows southward below Pendlestone Rock and High Rock towards the bridge and Bylet in Low Town, Charles I declared this view point 'the finest promenade in his dominions'.

THE SEVERN VALLEY RAILWAY

The arrival of the Severn Valley Railway heralded in a new era of trade and commerce for Bridgnorth, principally coal and agricultural produce although it further brought about the demise of the inland river port in Bridgnorth Low Town. Work started on the Severn Valley in 1862, between Hartlebury on the GWR Oxford Worcester & Wolverhampton Railway to Shrewsbury. The line passed through Stourport-on- Severn, Bewdley, Arley, Highley, Hampton Loade, Bridgnorth, Linley Halt, Coalport, Ironbridge & Broseley, Buildwas, Cressage and Berrington before reaching Shrewsbury. The SVR was absorbed by the GWR in 1872, which proceeded to build a connecting spur to Kidderminster – opened in 1878. The SVR had junctions to the Tenbury & Bewdley Railway opened

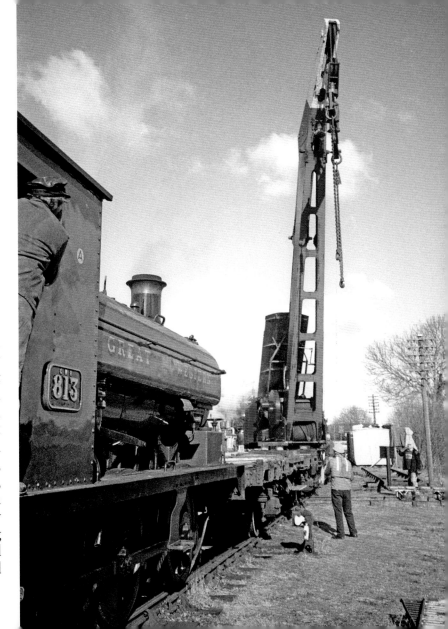

in 1864 via Bewdley and the Much Wenlock & Severn Junction that opened in the same year as the SVR (1862). Another connection was made to the GWR Coalbrookdale line at Buildwas in 1864.

The SVR closed in part in 1963 along with the Wenlock branch and the track north of Bridgnorth was soon lifted. The coal services to Arley sidings closed into 1969 and the T&BR line close between 1964 and 1965, Bewdley passenger service ended in 1970. The preserved Severn Valley Railway covers 16 miles from Bridgnorth between Shropshire and Worcestershire and follows for most part the course of the River Severn between Bridgnorth and Bewdley before diverging to its southern terminus at Kidderminster. The Mercian Way National Cycle Route 45 between Chester and Salisbury follows both the preserved SVR and the River Severn for part of the way between Bewdley and Bridgnorth.

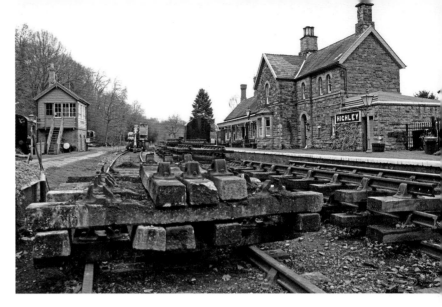

Above right: Highley SVR station during rebuilding of the line following heavy flooding and wash-outs in 2007, the line came under engineering works for almost a year before reopening for passenger services.

Opposite left: Station Lamp Bridgnorth at the start of the preserved section of the Severn Valley Railway.

Opposite right: A station lamp at Bewdley on the SVR, the last station along the Severn served by the preserved railway. Bewdley was a railway junction between Stourport and Hartlebury, and a branch that crossed the Severn at Dowles Bridge into the Wyre forest to Tenbury Wells, both these lines are closed. The present SVR leaves the River Severn at Bewdley and continues to its present-day terminus at Kidderminster.

QUATFORD

The Severn Way and the Geopark Way, another long-distance, walk leave Bridgnorth on opposite sides of the river. The Severn Way making its way south on the west bank of the river by way of Daniels Bridge (location of a working flour mill), Eardington and the site of a former iron works that cast cannon for the Crimean War, then on through Chelmarsh to Hampton, and the SVR station at Hampton Loade. Meanwhile the Geopark Way takes the west bank of the Severn parallel with the A442 Bridgnorth Kidderminster road for 2 miles to the small and ancient settlement of Quatford, recorded in the Domesday Book in 1086 as a fording point protected by a motte-and-bailey.

The motte-and-bailey lie beside Camp Hill a large dune-bedded sandstone outcrop that butts out into the river, and abruptly diverts the Severn South. The Geopark Way then diverts eastwards from the river at St Mary Magdalene Church and the Danesford Inn Quatford, joining woodland paths which lead to Dudmaston Pools. Crossing the busy A442, a public path skirts Dudmaston Hall Big Pool, through the Dingle at the edge of the Long Covert to emerge by Chelmarsh aqueduct at Hampton Loade and the banks of the Severn.

HAMPTON LOADE AN ANCIENT FERRY

For centuries, the civil parish of Chelmarsh on the west bank of the Severn was served by a ferry that crossed to Quatt and Malvern the parish on the east bank of the Severn at Hampton Loade. Hampton was the name of the settlement on the Severn, Hampton Loade was the Saxon name for the ferry, which was on the opposite side of the river and village – that is until the arrival of the railways, when the SVR renamed the village Hampton Loade, possibly to avoid confusion with other stations called Hampton.

Above: Red Rock and the site of an ancient motte-and-bailey fortification, built as a defence against Viking invaders.

Below: The view of the Severn Valley and the SVR from Rookery Cottage at Dudmaston.

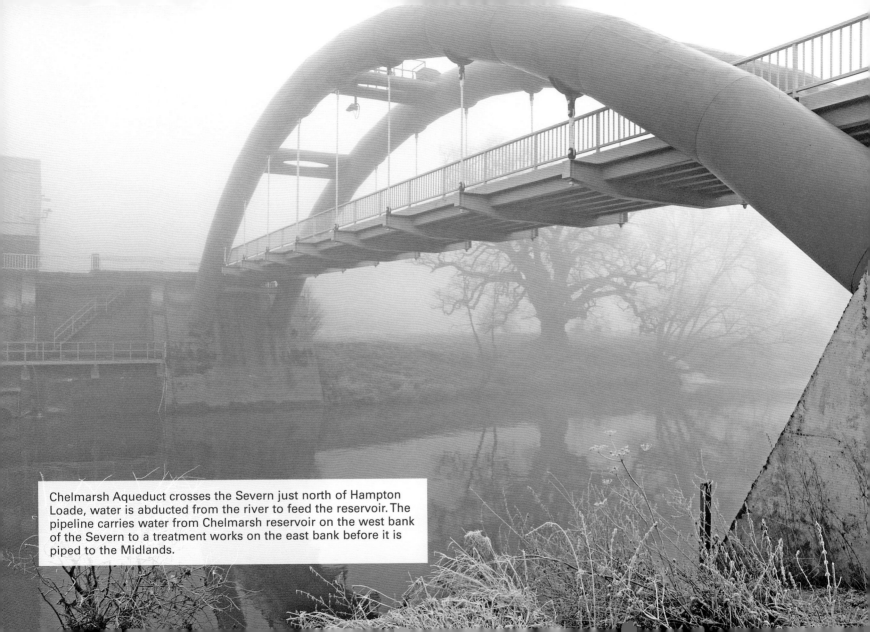

Chelmarsh Aqueduct crosses the Severn just north of Hampton Loade, water is abducted from the river to feed the reservoir. The pipeline carries water from Chelmarsh reservoir on the west bank of the Severn to a treatment works on the east bank before it is piped to the Midlands.

A cable-operated ferry still runs from Hampton at the end of the lane near the grounds of the Unicorn Inn and campsite, and a little way away from the SVR station incorrectly named Hampton Loade, this occasional service operates in the summer months. Dudmaston Hall is half-a-mile away from the National Trust riverside car park and from the River and Rail pub on the east Hamton Loade side of the river; both are accessible from the A442 Kidderminster Bridgnorth road. Regardless whichever side of the river one chooses, Hampton and Hampton Loade both offer an opportunity for exploration and a suitable stop for refreshments. The Geopark Way takes a route to an old Stone Buttercross at the edge of the parish of Alveley, while the Severn Way winds its way between the preserved SVR line and the river Severn towards the Village of Highley.

HIGHLEY AND ALVELEY

Highley and Alveley are on opposite banks of the Severn, both were once busy and industrious mining villages up until the end of the 1960s when the last pithead closed

Above: Seen together the SVR railway, the Mercian Way long distance path NCN Route 45 and the River Severn.

Below: The cable worked Hampton Loade Ferry, between the loade on the east bank and Hampton on the west bank of the Severn.

at Alveley. The mine's coal washers and railway sidings on the SVR were linked to the pithead at Alveley across the Severn by a 180 feet continuous concrete beam bridge and coal tub trackway, built by T. Beighton Ltd 1936. The bridge was converted into a footbridge by the county council in 1969 after the closure of the mine. A purpose-built footbridge, erected in 2006, has now replaced the old and demolished miner's bridge. The two long-distance paths the Severn Way and Geopark Way once again meet here, at the new Alveley/Highley Severn footbridge, and from here it is possible to follow the riverbank on either side of the river as far a Bewdley. Alveley village is certainly an ancient village the church of St Mary was founded in Saxon times, part of the present church dates back to Norman times, and the Three Horse Shoes is allegedly the oldest pub in Shropshire. The village also has a grimmer past; during 1349, food was left at the Buttercross for quarantined villagers during an outbreak of the Black Death, when over two-thirds of the village population died from the disease.

Today both sides of the river have a number of attractions worth visiting, at Alveley the old coal spoil heaps have been transformed into the Severn Valley Country Park and

Above: The Ship Inn, formerly a mug house at Highley, today a popular riverside stop for walkers and visitors who arrive by train on the SVR.

Below: Highley and Alveley bridge on a crisp but sunny winters day.

The Severn and Borle Brook at Brooksmouth Farm was once a busy interchange between the SVR and the Billingsley Colliery Railway which followed the course of the brook to the old pack horse bridge and the railway sidings of the colliery.

visitor centre. The park extends to the Highley side of the Severn, and it can be easily reached from the SVR Highley Station or Country Park Halt, which serves a picnic area in the park. At Highley station, the SVR has an Engine House Visitor Centre, and further toward the village is another part of the Severn Valley Country Park at Stanley, with a memorial to the mining heritage of the area. The Ship Inn on the banks of the Severn at Highley is another former riverside mug house, a onetime meeting spot for the old trowmen to drink and conducted business. The recently refurbished Ship Inn certainly remains a suitable spot to sit and observe the river as it flows to the county boundary between Shropshire and Worcestershire.

UPPER ARLEY

Before leaving Shropshire, the Severn is joined by another of its tributaries Borle Brook at Brooksmouth Farm. The Severn crosses into Worcestershire 1 mile northeast of Arley, the boundry is defined by a brook that flows from Button Oak in the Wyre Forest. Like Hampton Loade a rope-worked ferry connected the village of Upper Arley on the eastern bank of the Severn to a lane that runs to Button Oak in the Wyre Forest. The landing stages of the ferry on both sides of the river are clearly discernible and all that is lacking is the ferryboat that sat out its final years at Bewdley before being lost in recent floods. The ferry was replaced with a footbridge, which crosses the Severn and allows access for the villagers to Arley station on the SVR and the remaining pub in the village the Harbour Inn another historic mughouse. The Valentia Hotel was a former hostelry in the village named after George Arthur Annesley, the Viscount Valentia – the nineteenth-century owner of the Arley estate, which was closed in the 1970s. In the thirteenth century Upper Arley belonged to Roger de Mortimer and up to the late nineteenth century, was once part of Staffordshire; it is now the first Worcestershire village on the Severn.

At the top of the village, beside the entrance to St Peter's Church, is Arley Arboretum, which once formed the gardens of Arley Castle (demolished in 1960s). The North Worcestershire Path from Bewdley and the Severn Way path both cross at the footbridge, the North Worcestershire

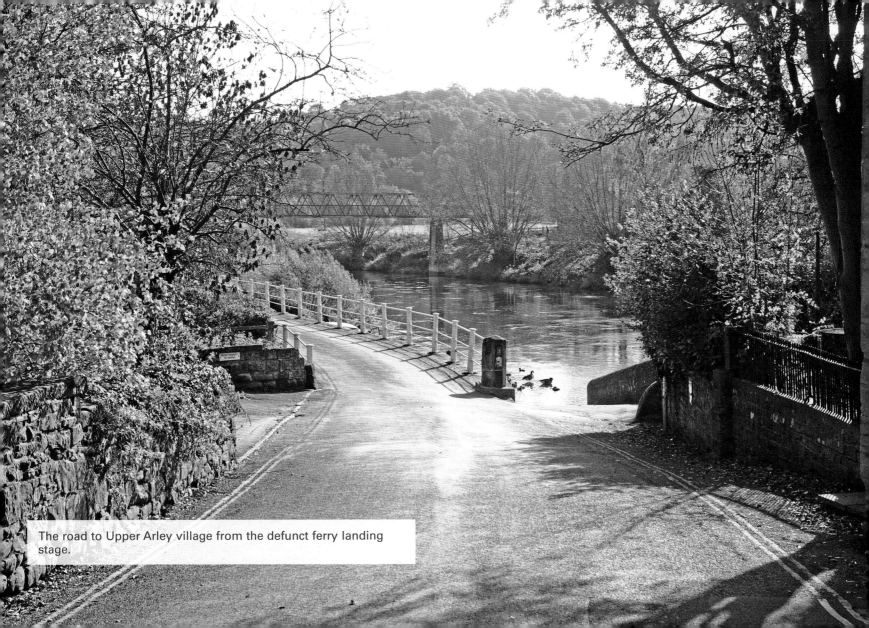

The road to Upper Arley village from the defunct ferry landing stage.

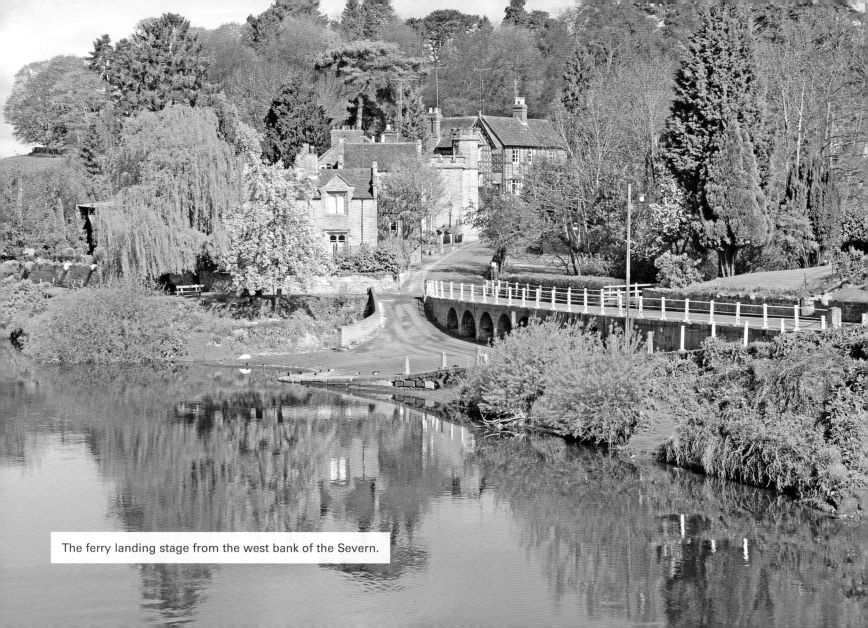
The ferry landing stage from the west bank of the Severn.

path heads off through Eymore Wood while the Severn Way follows the west bank of the Severn to Victoria Bridge and Trimpley Reservoir. Victoria Bridge, designed by John Fowler (1817–98) for the SVR was built in 1861; the bridge is a sister of the Albert Edward Bridge at Coalbrookdale. The Severn takes a sharp 'S' shaped turn after the bridge between The Medows and the steep-sided valley of Seckley Wood part of the Wyre Forest, before emerging in a stretch of rapids at Folly Point. The former Seckly Ford once crossed between the two densely forested banks of the Severn, before all trace of it was lost following the building of Trimpley Reservoir in the 1960s. A little further below Folly point is the Elan Valley Aqueduct that crosses the Severn. The aqueduct carries the water supply pipeline from Rhayader in Wales to Birmingham, a remarkable feat (of engineering) given that it has no pumping stations along its route, flowing along a natural gradient under the influence of gravity. The Severn now flows south for a further 1¼ miles before it reaches another structure that once spanned the Severn, this time the derelict railway viaduct that took the GWR T&BR across the Severn into the Wyre Forest and Cleobury Mortimer.

Above right: The ferry landing stage at Upper Arley village.

BEWDLEY A GEORGIAN TOWN

Dowles Bridge, north of Bewdley, is a towpath bridge that crosses a tributary of the Severn called Dowles Brook. It also lends its name to another much larger bridge constructed on stone pillars the Dowles Railway Bridge or viaduct, which carried the T&BR branch line from the SVR through the Wyre Forest. The line opened in 1864, closed in 1965, and today forms part of the Mercian Way National Cycle Route 45 and the Geopark Way.

The Severn flows past North Wood bank and the Bewdley Rowing Club steps on the east bank and Severnside North on the west bank a former riverside quay, now home to cafés, a pub (a traditional mughouse inn) and riverside

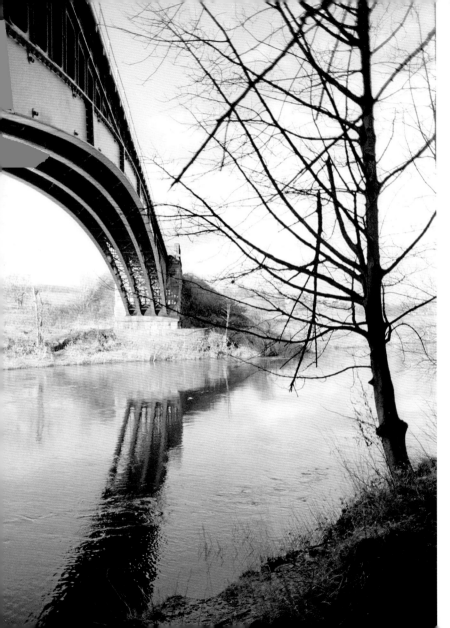

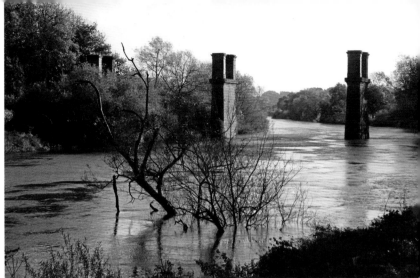

Above: The pillars of the lost Dowles Bridge 1864, which carried the Tenbury & Bewdley Railway through the Wyre Forest.

Left: Victoria Bridge crosses the Severn at Upper Arley, cast by the Coalbrookdale company in 1862, the bridge was designed by Sir John Fowler, and is a sister bridge to the Royal Albert Bridge at Coalbrookdale.

Opposite top right: The Severn Bridge at Bewdley designed by Thomas Telford and built in 1798, looking towards Wribenhall and the Kidderminster Road.

Opposite below right: …the carriage way of the bridge looking towards Loade Street…

cottages. Once a notorious spot for annual flooding, this was resolved when the foundations for an erectable barrier were sunk into the old quayside.

Bewdley Bridge designed by Thomas Telford links Wribbenhall and Bewdley. Bewdley grew on the western bank of the Severn up from the river and along Load Street to St Anne's Church at the junction of High Street. Wribbenhall and its quayside developed on the eastern bank. Telford's three-arch bridge replaces a bridge lost during the severe floods of 1795, and it divides the riverside frontages between Severnside North and Severnside South's predominantly Georgian housing and former warehouses, now converted to flats and apartments. A mile below Bewdley, having passed under the A456 road bridge, the Severn once again takes a dramatic turn as it comes up to Black Stone Rock. A place of myth and folklore the rock was a shelter for hermits and a refuge for travellers awaiting suitable periods of low water before attempting to cross the Severn at the nearby shallows.

The river was shallow at this point as a natural sandstone bar extended into the river, the crossing was totally lost after attempts were made to blast a navigable channel through the stone, and then ultimately lost forever when Lincomb weir was built and the level of the Severn was raised above Stourport as far as Bewdley. On the west bank of the Severn is Ribbesford and St Leonard's church, which date from the twelfth century. Bewdley Church did not have a cemetery so coffins had to be brought to Ribbesford's church for burial by a tree-lined avenue that came to be known as the Coffin Way.

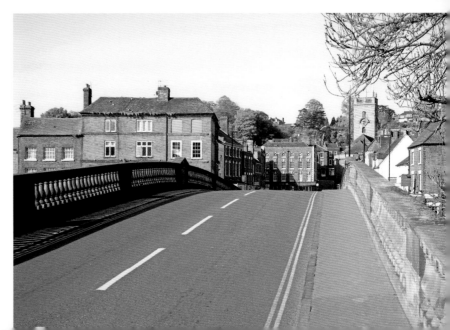

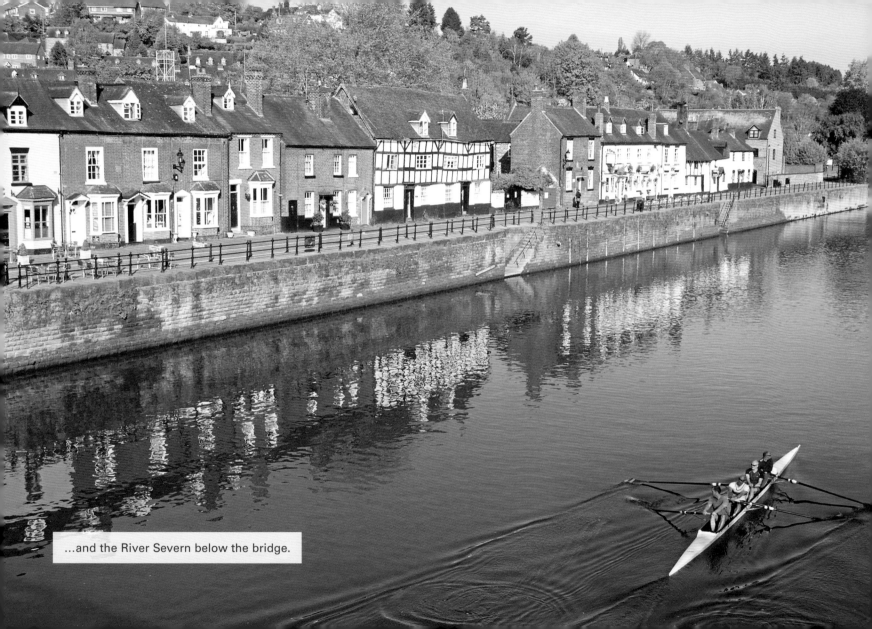
...and the River Severn below the bridge.

5

STOURPORT-ON-SEVERN TO UPTON-UPON-SEVERN

The 'middle navigation' portion of the Severn that once reached Welshpool in Powys today only extends upriver as far as Stourport-on-Severn in Worcestershire. This navigable portion of the Severn also happens to be the area most affected by the annual flooding of the river. In the nineteenth century, commissioners were appointed to improve the otherwise natural river navigation, and various acts of parliament granted the building of weirs and locks that raised the river levels. The century saw the canalisation of the Severn to Lincomb Weir below Stourport, these actions improved navigation between Gloucester and Stourport and helped to further develop Stourport, Worcester and Gloucester as major canal ports serving the Midlands, ideally suited to the transportation of bulk goods such as petrochemicals, timber, grain and coal. The national canal and railway networks were more than adequate for the transhipment of goods and produce from these river ports, sometimes bound for otherwise lightly industrialised towns further up the Severn, and as canals and railways declined in importance, roads and not rivers became the main arteries of trade along the Severn Valley. Navigation above Stourport is unlikely to return, and locks and weirs would be an extreme extravagance if navigation were the only objective, however the canalisation and building of weirs (dry dams) on the Severn may well have another purpose: that of regulating river levels and minimising the effects of flooding. Flood relief on the Severn has never been more important, especially since recent decades have seen more frequent heavy rainfalls, a substantial increase in impervious surface and construction on the natural flood plain, which has resulted in the loss of natural wetlands and bodies of water, if not global warming. The natural drainage and runoff from fields and urban areas in the Severn River Basin has a significant strain on surface flooding and pollution. In comparison to the upper reaches of the Severn above Stourport the river levels between Stourport, Worcester and Upton-upon-Severn appear higher, and there are noticeably fewer extensive shallows in the river, but more noticeable is the appearance of river traffic.

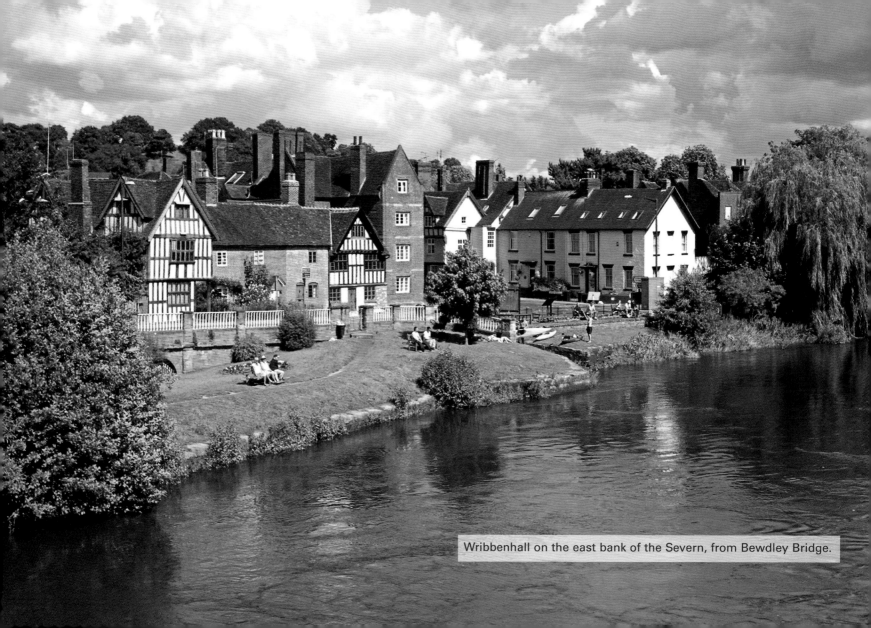
Wribbenhall on the east bank of the Severn, from Bewdley Bridge.

STOURPORT-ON-SEVERN TO UPTON-UPON-SEVERN

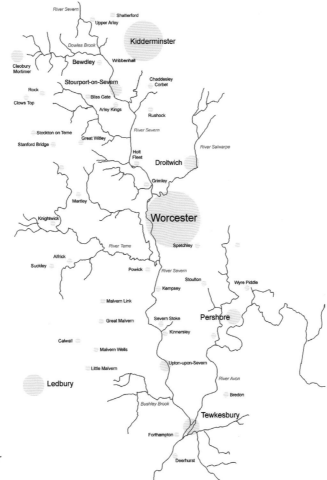

The Severn in Worcestershire Lithograph of Worcester Bridge and the copula of the church at Upton-upon-Severn.

Lithograph of Worcester Bridge from *Our Own Country,* 1881.

STOURPORT ON SEVERN: A CANAL TOWN

The Severn's 3½-mile route between Bewdley Bridge and Stourport Bridge takes it past Ribbesford Woods and Stagborogh Hill on its west bank, and Blackstone Rock and the heath land at Burlish Top on its east bank. The Severn Way follows the west bank of the river beside Woodgreen Farm and Lickhill Manor, before entering onto a half-mile riverside promenade that takes it to Stourport-on-Severn. The stretch of river at Lickhill Manor marks the furthest point of navigation on the Severn. Stourport-on-Severn is unique among towns in the British Isles in that the coming of the canals created it. The Staffordshire & Worcestershire was approved by Parliament on the 14 May 1766; the canal was engineered by James Brindley and opened in 1772. The basins, river locks to the Severn, and the confluence with the nearby River Stour at the village of Lower Mitton became the kernel of the port that came to be known as Stourport-on-Severn, once described as 'a complete maritime town in the heart of England'.

The present 150-foot-span cast-iron Stourport Bridge was built in 1794, rebuilt in 1870 by Thomas Vale, and further rebuilt and repaired during 2006–07 when faults were found in the structure. The present-day bridge replaced an earlier structure built in 1775, destroyed in the 1794 floods, Stourport Boat Club founded in 1876 stands on the west bank Arley Kings, Walshes side of the river.

The canal basins are located on the west bank, bound by Bridge Street, York Street and Mart lane, although a new basin has been dug on the opposite side of Mart lane. Re-excavated may be a better interpretation as the new basin, bridge and apartment blocks at Mart Lane where constructed on a previously filled-in basin that was used as a wood yard, the newly dug basin forms the focal point for equally new surrounding flats and apartments. The newly refurbished Tontine Hotel stands overlooking the Severn, similarly named to the Tontine Hotel at Ironridge, which stands facing the Iron Bridge. A tontine is a financial agreement that allows members entering the agreement to share a dividend from their investment, and divide among themselves the dividend and shares from deceased members. The last survivor inherits the full sum of dividends. At the riverside of Mart Lane is the Angel Inn and former vinegar works, the confluence of the river Stour and fields alongside Severn Side – the site of Stourport power station demolished in the1980s. The River Stour provided the cooling water, and for a time coal was transported by the Staff's & Worc's Canal or shipped to a wharf at the power station by river barges. A railway branch from the Hartlebury spur of the SVR carried coal to the heart of the station superseded both the canal and the river in the 1940s.

Commercial Wharves at Hartlebury handled barges laden with timber, coal, ironstone, grain imported from Sharpness and oil tankers discharged at the quayside at

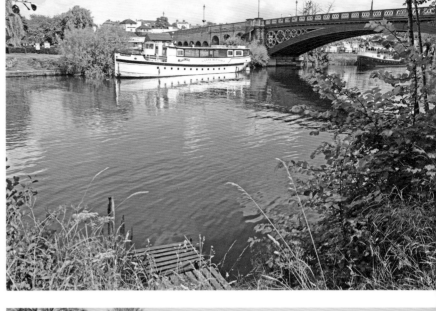

Above: Hire boats at Stourport-on-Severn.

Above right: Stourport-on-Severn pleasure steamer moorings above the present Stourport bridge built in 1870, the bridge replaced a former bridge built in 1806, and the one before that the original Brindley Bridge named after the engineer of the Staffordshire and Worcestershire Canal, built in 1775 and destroyed in floods in 1794.

Right: Stourport pleasure steamers below Stourport Bridge, which ply between Holt Fleet and Worcester during the summer.

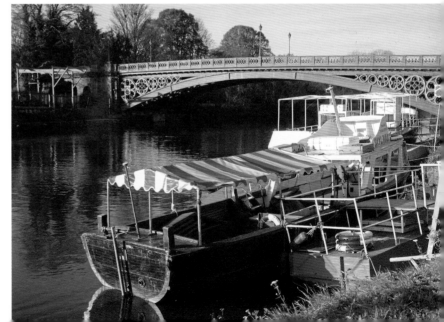

Sandy Lane storage facility. By the end of the twentieth century all commercial traffic to Stourport had disappeared, oil and petrol ceased in the 1960s. Stourport-on-Severn is now home to hire boats and pleasure-steamers that ply up and down river for short 40-minute cruises, or are available for hire, narrowboats and motor cruisers and the permanent Bridge Treasure Island Amusement Park that overlooks the Bridge Street Basin.

The town has always been a popular holiday resort, especially for visitors from Birmingham and the Black Country most of whom arrived by the Kidderminster & Stourport Electric Tramway. Although Stourport-on-Severn had a railway station, the services were less frequent than the K&SET tram from Kidderminster, which had a stop at Kidderminster GWR station and a terminus on Stourport Bridge. Immediately after the closure of the tram service, visitors took to the bus, and arrived by the Birmingham & Midland Red Motor Omnibus Co. Ltd. On either the X33 Dudley, 133 Birmingham or K33 Kidderminster services, most visitors today choose to arrive by car.

Opposite left: Navigation sign at entrance to Brindley's Staffordshire & Worcestershire Canal, the Staff's and Worc's connects the Severn to the Trent & Mersey Canal at Haywood Junction by Great Haywood east of Stafford.

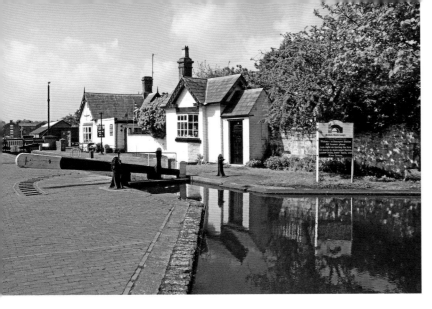
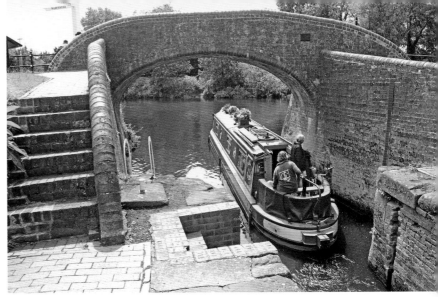

Above: The Staff's & Worc's Toll Office like many other features was built along with the canal in 1772.

Above right: A canal boat making its way out of Stourport Narrow Lock No. 1 from the Staff's & Worc's Canal onto the Severn.

Right: Stourport Bridge Basin and the amusement park.

LINCOMB WEIR TO HALT FLEET

The Severn Way continues along the east bank of the river beyond Stourport and the decaying gantry and piled outflow that directs the River Stour into the Severn, now the only witness to where Stourport power station once stood. The path crosses the entrance to Stourport Marina and alongside old wharfs and through a busy working boatyard. Directly opposite on the west bank is Redstone Rock a sandstone outcrop with hewn passages, hermitages, shelters for travellers and former ferrymen. Like Black Stone Rock at Bewdley, the river was also once a shallow forging point before Lincomb weir was built to permanently raise the height of the river. In 1502, the funeral cortege of the sixteen-year-old Prince Arthur crossed here on its way to Worcester Cathedral. Lincomb is the uppermost weir and lock in a system of locks built by the Admiralty during the1840s, each raised the river levels a few feet to aid navigation.

The Weir at Lincomb was constructed on the site of Cloth-House Ford that once connected to roads at Larford Farm on the west bank, to a lane at Titton on the east bank of the Severn, the name for the ford comes from the cloth fulling mills on Titton brook. The 100-foot-long and 20-foot-wide brick-lock chamber at Lincomb was constructed on the dry east bank of the river and channels were excavated to the upriver and downriver gates. The course of the navigable Severn was then permanently redirected through the gates when the channels were flooded.

A second similarly constructed weir six miles below Stourport is at Holt Fleet, on the west bank of the manmade island formed between the lock channels and the river. Further downriver from the weir is the cast-iron Holt Fleet Bridge designed and built by Thomas Telford and completed in 1828, the bridge spans 150 feet across the Severn. The Holt Fleet Hotel stands on the west bank south of the bridge on the site of an earlier Inn that catered for day-trippers from the Black Country and Midlands arriving by steamer from Stourport and Worcester. The Wharf Inn on the east bank retains riverside moorings, and is a fishery caravan and campsite. The Severn Way crosses Holt Bridge and heads off towards Holt and Grimley, crossing Grimley Brook beside Church Farm Quarry. Another long-distance path The Wychavon Way starts out towards Ombersley from Holt Fleet on the east side of the Severn. The village of Holt has a church that dates back to Saxon and Norman times, and a castle, which was once the residence of Walter de Beauchamp. The Severn Way continues through Grimley village and rejoins the Severn at the site of another defunct ferry, turning south to follow the river for a mile to Bevere Island and the third weir and lock below Stourport.

Opposite: Lincomb Weir built to raise the level of the Severn, the system of locks and weirs on the Severn were built to eliminate the hazards of navigation caused by variations in river levels and periods of low water.

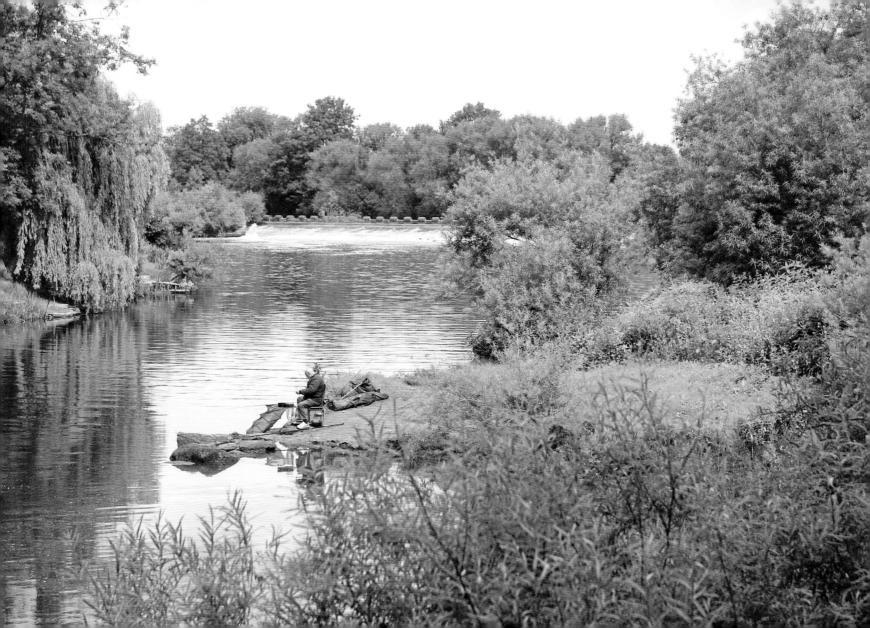

GRIMLEY & CLAINES

From Holt Fleet Bridge a public footpath heads south along the east bank of the Severn for approximately 2 miles to Bournes Dingle and Hawford Wood where it emerges from a lane onto the busy A449 dual carriageway. The roadside footpath along the northbound carriageway of the A449 heads south toward Hawford and the confluence of the River Salwarpe. A public footpath leaves the roadside path to join the towpath of the Droitwich Canal beside locks that lower the canal to the Severn. A path follows the east bank to Bevere weir and the circular 3-mile Northwick Manor Heritage Trail explores the riverside in the civil parish of north Claines. Although somewhat remote from the river, the Mug House Inn in the churchyard at Claines most definitely follows in the riverside mughouse tradition. A 1-mile direct route from Bevere lane crossing the A449 road and a footpath across fields connects the Mug House Inn and the Severn.

Another traditional mughouse is the Camp House Inn on the west bank of the Severn at Grimley, which takes its name from Bevere (Camp) Island in the river. The natural island before the weir and locks were built served as a

Above: The up-river entrance to Holt Fleet locks from the navigable east channel, the locks were constructed on dry land and a channel was dug to connect to them, the river took the natural west channel.

Below: Holt Fleet Weir from the west bank of the Severn.

Above: Bevere Lock 3 miles above Worcester.

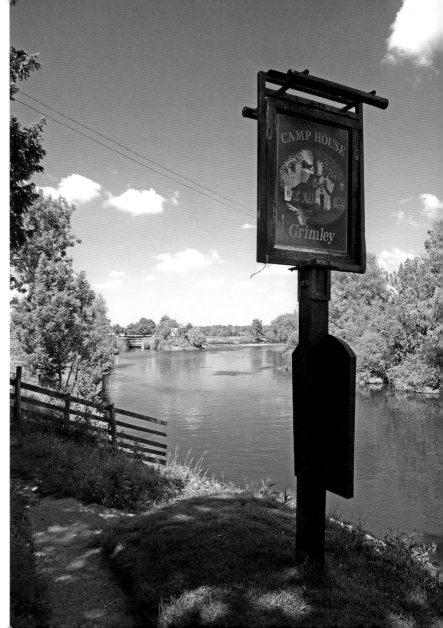

refugee camp during a seventeenth-century visitation of the plague and during the English Civil War. Oliver Cromwell licensed the inn after the battle of Worcester in 1651, and a punt ferry operated to Bevere Green on the Barbourne side of the Severn from Camp Lane and the Inn through Victorian and Edwardian times. The Severn Way continues to follow the west bank of the Severn for a further 2-miles south to the boundary of the city of Worcester.

WORCESTER

On reaching the city of Worcester the Severn passes the extinct Kepax Ferry – also known as Bailey's Boat, for the surname of a former ferryman and owner. Mr Bailey had six married daughters who lived in separate cottages on the riverside at Worcester, his ferry crossed over to

Above: The riverside Camp House Inn at Grimley licensed by Oliver Cromwell after the battle of Worcester in 1651, the inn takes its name from the Nearby Bevere Island formerly Camp House Island, which was a retreat for the inhabitants of Worcester from war and the plague.

Below: A canal boat entering Bevere lock. There are three potential circular cruising routes between the Severn and the national canal network, The Stourport Ring uses the Staffs & Worc's, Worcester & Birmingham canal (W&BC) and the Birmingham Canal Network (BCN), the Droitwich Ring, takes the Droitwich Canal and the W&BC. The third is the Avon Ring by way of the River Avon from Tewkesbury, Stratford & Avon Canal returning by the W&BC and River Severn.

Barbourne Park and Pitchcroft on the west bank of the Severn. A little further down river was the much older Dog and Duck ferry that also operated to Pitchcroft.

The ferry took its name from an inn of the same name, which in turn was named after a sport, namely that of setting dogs to catch ducks on the river; the cruel activity had stopped by the middle of the nineteenth century. The Severn passes the grandstand at Pitchcroft Race Course and Worcester Rowing Club before reaching Sabrina footbridge and the GWR viaduct that takes the Worcester Hereford line over the Seven. Racing at Worcester dates back to the early eighteenth century and rowing dates back to 1874 and the founding of the rowing club, although a succession of rowing events where held in the nineteenth century.

Former warehouses, the Old Rectifying House and Mellor's Sauce Factory – a rival manufacturer to Lea and Perrins, and its famous Worcestershire Sauce – stood below the railway viaduct at North Quay, built in 1860 (North Parade). A short length of railway descended down from the viaduct to run along the quayside beside

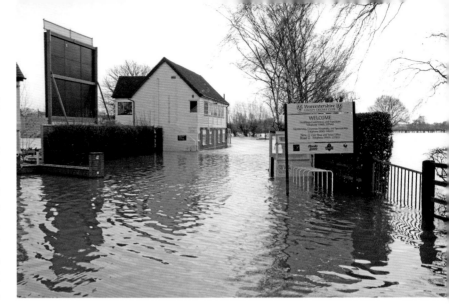

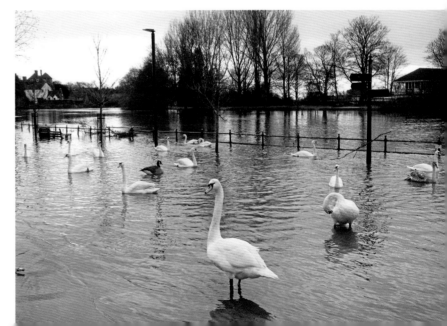

Above: Worcester Cricket Ground under water, almost a yearly event, the cricket ground is on the west bank of the Severn at St John's. Another sporting venue frequently under water is Worcestershire's Pitcroft Race Course, on the west bank of the Severn.

Below: Worcester has a large population of swans seemingly undisturbed by the regular flooding of the Severn.

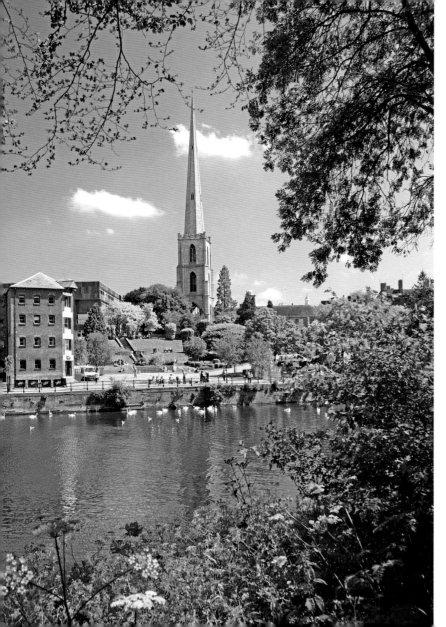
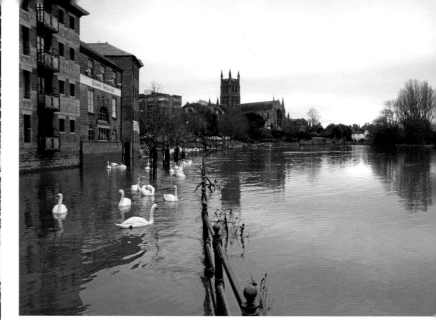

the Severn View Hotel formerly the Hope & Anchor Hotel and under an arch of the original Severn Bridge to wharfs and warehouses on South quay. Designed by John Gwynn in 1781 Worcester Bridge was widened in 1847 and completely rebuilt in 1931–32 to carry the widened A44/A449 trunk road, the short railway by then had been lifted.

Downriver of the bridge along South Quay is the former Firkins & Co. hop and seed merchants' warehouse, now converted to apartments and a restaurant. Behind the old warehouse is St Andrew's Church spire, which commemorates the 'glovers' who used to live and work in the area. The nave of the church was demolished in the 1940s and only the eighteenth-century spire, otherwise known as the 'Glover's Needle', remains. South Quay extends to the foot of Worcester Cathedral and the Deanery onto Diglis Parade. Worcester Cathedral in the diocese of Lichfield was the See of Archbishop Theodore of the Saxon Kingdom of Mercia. Under the guidance of Bishop Wulstan a later Saxon bishop, the cathedral and Benedictine monastery at Worcester was progressively built after the Norman Conquest.

An ancient ferry, once worked by monks from the priory, operated between the Cathedral steps and St John's on the east bank of the Severn. A plaque on the wall of the ferry steps reads:

> A ferry has operated at this point on the river for many centuries, carrying passengers between the Cathedral Watergate and the Chapter Meadows on the opposite bank.

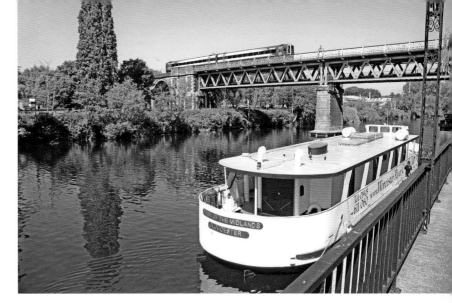

Above right: Steamer and the railway viaduct built in 1860 and rebuilt in 1904 the viaduct carries the former GWR Malvern and Hereford line across the Severn.

Opposite left: The Severn and the 245 feet in height Glovers Needle from the Bromwich Parade on the west bank of the Severn.

Opposite top right: A regular and now annual event Worcester in flood.

Opposite: below right: The race course grand stand built on the site of a former Grand Stand Hotel.

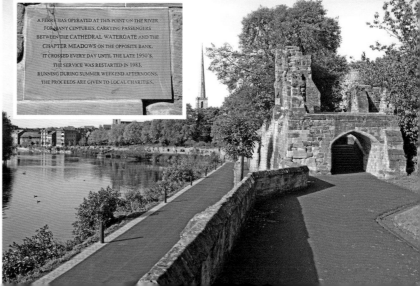

A FERRY HAS OPERATED AT THIS POINT ON THE RIVER
FOR MANY CENTURIES, CARRYING PASSENGERS
BETWEEN THE CATHEDRAL WATERGATE AND THE
CHAPTER MEADOWS ON THE OPPOSITE BANK.
IT CROSSED EVERY DAY UNTIL THE LATE 1950'S.
THE SERVICE WAS RESTARTED IN 1983,
RUNNING DURING SUMMER WEEKEND AFTERNOONS.
THE PROCEEDS ARE GIVEN TO LOCAL CHARITIES.

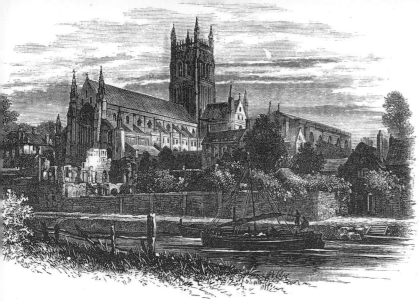

WORCESTER CATHEDRAL, FROM THE RIVER.

Above: Lithograph of Worcester Cathedral and Severn Trows.

Right: Worcester Cathedral and the deanery gardens.

Opposite left: The Cathedral ferry steps. The Cathedral ferry crossed between Chapter Meadows, now the County Cricket Club grounds, and the cathedral steps.

Opposite top right: The Cathedral ferry.

Opposite below right: The deanery gardens to the South Quay south of the Glovers Needle.

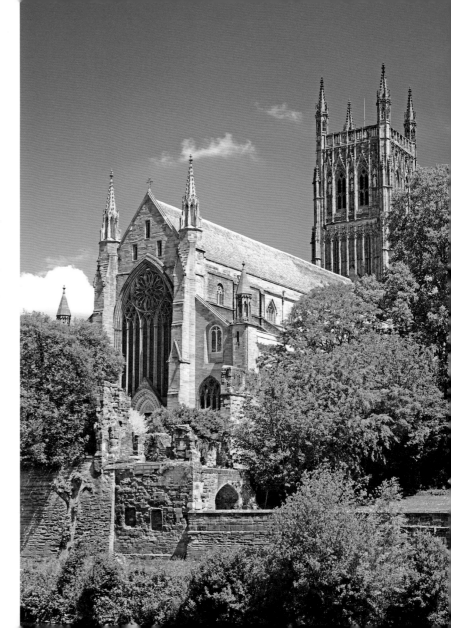

Worcester and the west bank flood meadow between Weir Lane and Bromwich Road.

The ferry was abandoned in the 1950s but restarted in 1983, and now operates during summer weekends with the takings given to local charities. Returning to the west bank of the Severn below Worcester Bridge the Bromwich Parade path follows the river south past Worcester County Cricket ground to the next weir at Diglis.

DIGLIS LOCKS & WEIR

The Worcester & Birmingham Canal runs 30 miles from Diglis Basin on the Severn to Birmingham Gas Street Basin.

The locks onto the Severn are 14-feet wide to allow river craft to enter Diglis basin form the Severn, the remaining locks on the canal are for narrow boats 7-foot wide. The massive 500-foot long Diglis Weir raises the river level between Worcester and Tewkesbury. Both the lock and weir were built on dry land, and a new river channel was directed to the lock pounds, the existing river channel was closed in a ceremony witnessed by city dignitaries, invited guests and onlookers and the old course of the river was later filled in.

Downriver of Diglis weir is Diglis Footbridge, constructed in 2010 it carries Route 46 of the National Cycle Network. Nearby at Powick is the confluence of the River Teme. The old Powick Bridge over the River Teme was the location of the first cavalry engagement in the Civil War between the King's forces under the command of Prince Rupert with the Parliamentary Army commanded by the Earl of Essex (1642).

The fields below Powick were also the location of the last battle in the Civil War and the Battle of Worcester that led to the defeat of Charles II in 1651.

Opposite left: Entrance to Worcester and Diglis canal basin.

Opposite right: During the autumn of 2011 the larger lock was drained, cleaned and repaired.

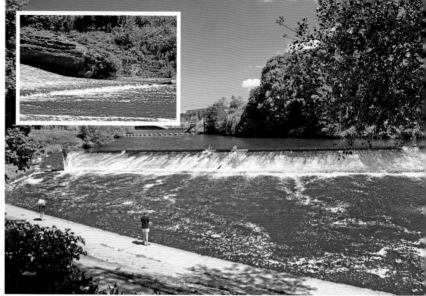

Above: Diglis weir and a hungry heron.

Above left: Entrance to Diglis basin and the Worcester & Birmingham Canal.

Left: Diglis River Locks the large lock is 33 feet wide and 151 feet long and 36ft deep and was used for larger vessels bound for the river port at Diglis, the smaller lock was used for traffic up to Stourport.

UPTON-UPON-SEVERN

The Seven Way continues south alongside the Severn through low river terraces and meadows called 'hams' for 3 miles to the Village of Kempsey, and then through the civil parish of Severn Stoke in sight of the distant Malvern Hills beyond the west bank of the river. The church of St Mary the Virgin at Kempsey stands over an old ford, from here the Severn Way follows the bank of the Severn for 1-mile below the village, before it heads off over fields to Clifton Farm. After its 2-mile departure the Severn Way path returns to the river for a short distance before it once again leaves the river for 1½ miles at Severn Bank to take a diversion by Severn Stoke and the A38 road to circumvent Cliff Wood. Within a further 1½ miles, the Severn reaches Upton Bridge and the distinct riverside landmark 'Pepper Pot' tower of St Peter and Paul.

Upton-upon-Severn was a crossing point from Tudor times. The ancient ferry was replaced by a succession of bridges. The present bridge dates from 1940 it replaced an earlier bridge which was built in 1854 and constructed with a draw-section of roadway, later replaced with a swing-section carriageway in 1883. The pivot abutment of the former bridge stands next to the moorings on the town side of the river.

Upton-upon-Severn has always experienced heavy floods especially in recent years when riverside properties including, the Swan Hotel, The Kings Head and The

Marina Upton-upon-Severn.

Plough Inn suffered flooding almost on an annual basis. The unexpected summer floods of 2007 saw the whole town overcome by a flash flood from a very-unexpected direction the high street. The Environmental Agency has since implemented more permanent flood protection by building floodwalls and raised walkways. The other significant riverside construction at Upton-upon Severn was the construction of the Marina for pleasure craft in the 1970s. Below Upton, the Severn Way passes riverside meadows of Upper Ham Nature Reserve (designated as a Site of Special Scientific Interest), leaving Lower Ham at Sandy Point. On the east bank of the Severn another lost ferry at Saxon's Loade once served the two small villages

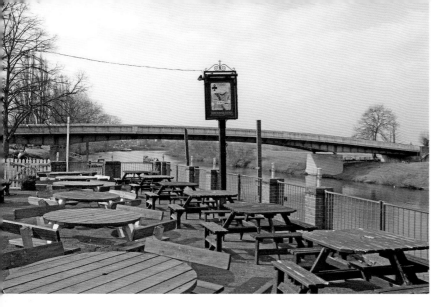

Uckinghall and Ripple, both with interesting ancient crosses at the centres.

The M50 road bridge crosses the Severn less than a mile below the villages, the Severn Way crosses Bushley Brook and within 1 mile meets the 9 mile Worcestershire Way Link path beside the Severn. The course of the river for the next mile actually marks the boundary between Worcestershire and Gloucester, and the Severn Way passes through Worcester into Gloucester at the Mythe Bridge.

Above left: Upton-upon-Severn Bridge.

Left: Passenger Steamer at Upton-upon-Severn.

Opposite: Muddy and ebbing flood waters at Upton-upon-Severn.

6
TEWKESBURY TO GLOUCESTER

The southernmost boundary of Worcestershire runs along the course of the Severn for 2½ miles from Windmill Tump to Upper Loade. The A438 Tewkesbury to Ledbury road over Mythe Bride crosses the county boundary between Worcestershire on the west bank and Gloucestershire on the east bank of the Severn. Designed by Thomas Telford and opened in 1826 the bridge spans the two counties on its 170-foot long and 24-foot wide carriageway, the tollhouse is on the east bank of the river and traffic is in single file controlled by traffic lights. The Severn Way also crosses the bridge from the west bank and continues south to the confluence of the Old Avon before turning back to Beaufort Bridge, the Mill Avon and Tewkesbury Abbey.

The A38 passes through Tewkesbury, crossing the Mill Avon on King John's Bridge and the Old Avon on Beaufort Bridge. There has been a succession of bridges over the Avon here since the sixteenth century, but no bridge over the Severn until the building of Mythe Bridge in the nineteenth century. The earliest bridge was a series of stone arches spanning both channels of the Avon; in 1675, there were two separate stone bridges, each with stone arches. In the nineteenth century the causeways beyond the Old Avon, were widened and raised. In 1962 the old bridges and causeways were rebuilt in stone and concrete, retaining some of the old features, and opened as King John's Bridge over the Mill Avon and Beaufort Bridge over the Old Avon.

The crossings of the Avon and Severn make Tewkesbury the quintessential riverside town; standing at the confluence of two rivers the Severn and the Warwickshire Avon. Two tributaries the River Swilgate and Carrant Brook join the Avon in the town. The surrounding area and the Severn Ham forms the extensive floodplain, it has navigable waterways, weirs, locks, bridges, a water mill and a marina. Despite its favourable location at the confluence of two navigable rivers, navigation between Upper Lode at Tewkesbury and Gloucester is at best hazardous, principally due to high water levels and tidal conditions,

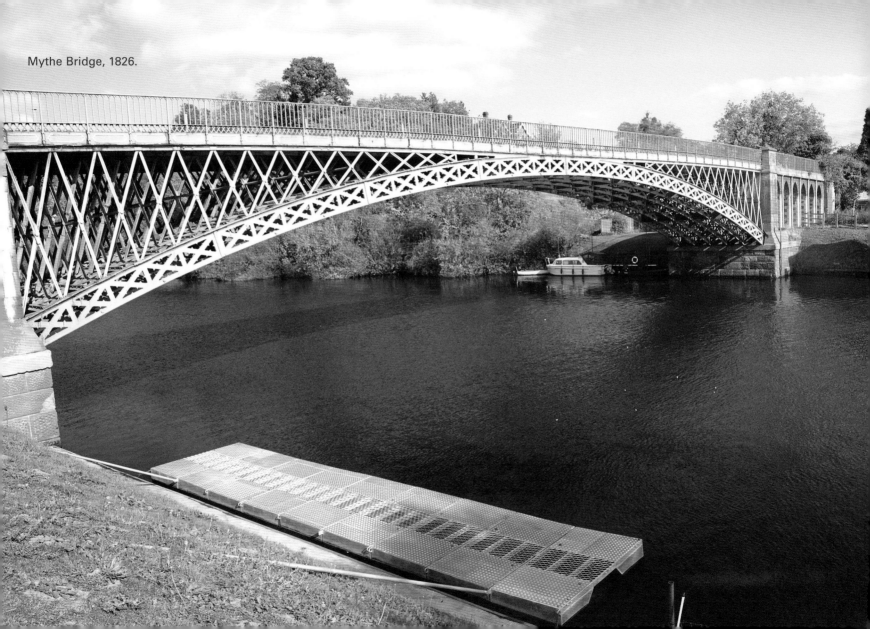
Mythe Bridge, 1826.

106 RIVER SEVERN

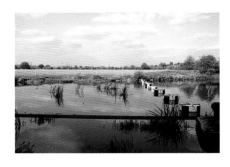

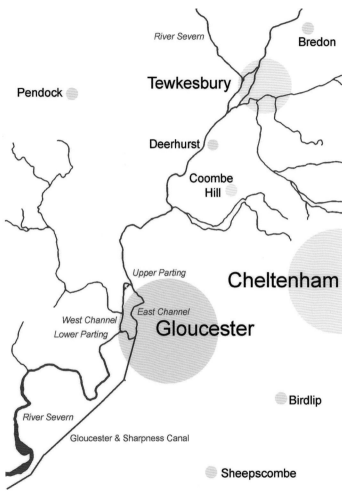

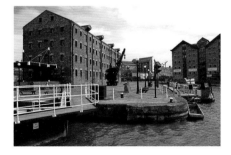

Tewkesbury, Gloucester Docks and the Vale of Berkeley.

at full moon and new moon spring tides overtop the weir at Maisemore. The weirs at Maisemore and Llanthony at Gloucester maintain the water level on this stretch of the Severn.

A feature of the Severn below Tewkesbury is the more expansive flood plain, a sign that the Severn has reached 'old age', also the river splits 3 miles above Gloucester into two separate channels, the eastern channel is navigable, the western unnavigable channel takes the natural river to Lower Parting where the eastern channel rejoins it.

TEWKESBURY

The Severn and the Warwickshire Avon lie west of Tewkesbury. The Avon splits into two channels: the Mill Avon, an artificial channel dug by the monks of the abbey to feed the Abbey Mill; and the River Swilgate, which joins the Mill Avon below the weir. The upper part of the Mill Avon is navigable up to the weir at Abbey Mill, a lock between King John's Bridge – the middle arch of which allows pleasure cruisers to pass – and the bridge at Quay Street beside the red-brick Healings Flour Mill connects with the Old Avon. The Avon's other channel, called the Old Avon, starts at a weir between the town's two marinas, Carrant Brook joins it opposite the weir and boats from the lower marina are able to navigate under Beaufort Bridge.

The Gloucestershire Way meets the Severn Way at Abbey Mill, which stands on the Mill Avon channel; the famous 'Abel Fletcher's Mill' in Dinah Maria Craik's novel *John Halifax, Gentleman* (1856). Another mill that stands beside the Mill Avon is Healings Flour Mill, which dates back to 1865 and was once considered to be the largest and best-equipped flourmill in the world; it closed at the end of 2006. Healing's operated a fleet of grain carrying vessels on the Severn. Grain was loaded into barges, either wheat imported by ship from Europe to Sharpness docks or English wheat loaded at Gloucester docks. The journey from Gloucester docks up the Severn to Tewkesbury with a fully loaded 250 tonne barge normally took about four hours dependent on the river levels, which were perilously low during the summer – especially in the navigable east channel (Parting) at Gloucester. Bulk cargo vessels often ran aground at shallow spots, and on occasion had to be towed-off. Fully laden upstream barges turned into the Old Avon to berth below the mill after locking through Upper Loade; the grain was then piped to the on shore storage silos. The holds were washed and the vessel usually returned to Gloucester the same day.

The Mill Avon to the west and Severn to the east effectively form an island between them called the Severn Ham, which is part of the natural flood plain of both rivers, vital to the regulation of annual flooding. The Severn Ham comprises of approximately 166 acres of common access riverside meadowland, and sheep are often seen grazing and climbing on the banks of both rivers. Concern has

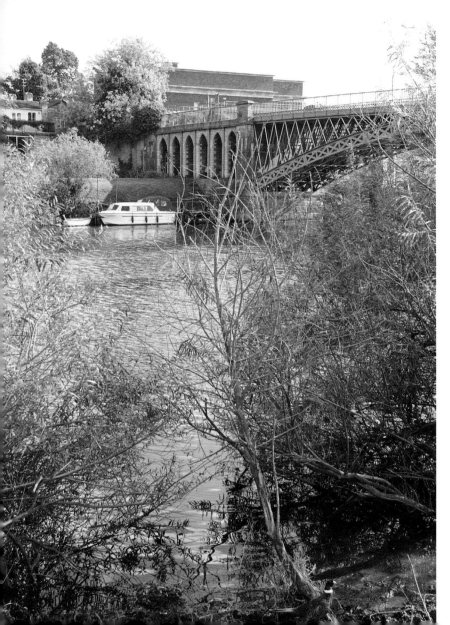

been expressed locally that the future development of the redundant Healings flourmill for housing development, risks the loss of this natural environment used by walkers, grazing livestock and wild life.

The tower of Tewkesbury Abbey dominates the surrounding skyline. The abbey church was once part of a Norman Benedictine monastery, consecrated in 1121.

In 1471, Lincoln Green and Bloody Meadow below the abbey was the site of the battle between the houses of York and Lancaster in the Wars of the Roses. The abbey church was also the site of a massacre of Lancastrian soldiers seeking sanctuary after their defeat. Tewkesbury parishioners saved the church after the dissolution in 1540 when it was bought from the Crown for £453. The Abbey Lawn Trust protects the area surrounding the abbey from development. Other notable buildings are the Bell Hotel opposite the Abbey gateway mentioned in Charles Dickens' *The Pickwick Papers*, The Royal Hop Pole Hotel in Church Street, the House of the Nodding Gables (Key House) High Street, and Tewkesbury's oldest public house the Black Bear, which dates from 1308 – beside the Mill Avon,

Two now-defunct ferries served the abbey, at the Upper Lode and Severn Ham and the Lower Lode at the confluence of Mill Avon with the Severn. The Lower Lode ferry operated between the abbey and its grounds at Forthampton Court.

Mythe Bridge near Tewkesbury designed by Thomas Telford, it carries the A438 road.

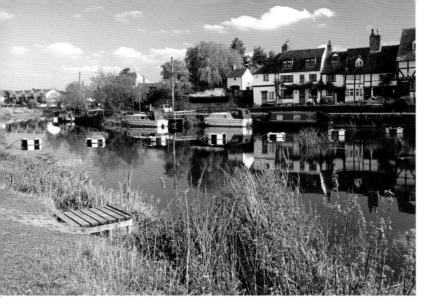

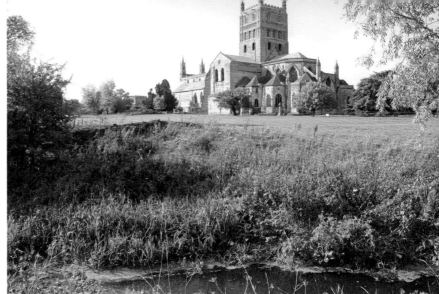

Above: The Warwickshire Avon at Tewkesbury.

Above right: Tewkesbury Abbey overlooks three rivers the Severn and the Warwickshire Avon to the north, and the River Swilgate seen here passes south of the abbey before joining the Mill Avon.

Right: The ferry at the confluence of the Mill Avon.

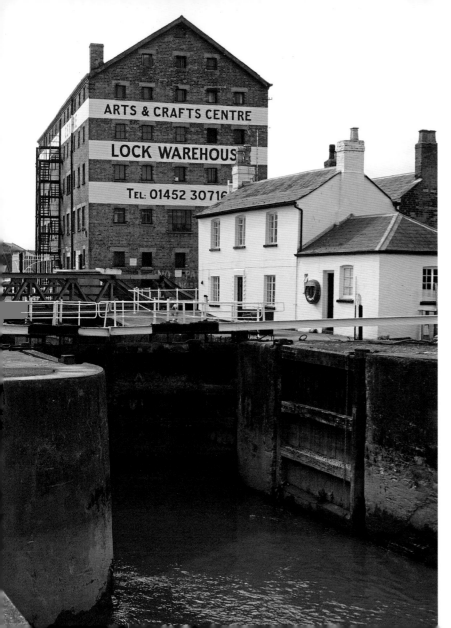

THE PARTINGS

The Severn Way leaves the confluence of the Mill Avon and extant working ferry at Lower Loade Tewkesbury by the west bank of the Severn and in 1½ mile arrives at the lost Saxon priory and St Mary's Church at Deerhurst beside Odda's Chapel 1056 a surviving Anglo-Saxon chapel incorporated into a sixteenth century farmhouse. The lane from the village of Chaceley leading to the west bank of the river and the Yew Tree Inn once called the Old Ferry Inn, opposite to Deerhurst is another lost ferry on the River Severn.

In a further 2 miles is the Haw Bridge between Apperley in the civil parish of Deerhurst and Tirley on the west bank of the Severn. The Severn continues south for 3 miles around Sandhurst Hill, with the village of Ashleworth on the west bank. An ancient ferry once crossed from Ashleworth Quay to Rodway Lane and Sandhurst village it closed in the 1950s. Roman remains at Ashleworth Quay indicate that the crossing was probably of great antiquity and certainly, the crossing was used in medieval times. In 2½ miles the Severn reaches the weir at Maisemore and the Vale of Gloucester. It is possible to follow the Severn along footpaths on both sides of the river. From the bridge at Upton-upon-Severn it is 17 miles, and from the Mythe Bridge at Tewkesbury it is 11 miles to Maisemore Bridge north of Gloucester. The Severn divides

Entrance to Gloucester Docks and the Gloucester & Sharpness Canal.

into two channels at Upper Parting the Severn Way follows the East Channel.

The west channel flows over the weir at Maisemore beside the defunct river lock, and then alongside of the A417 road to Alney Road Island and the A40 road crossing of the river at Over Bridge. The west channel can be followed by crossing Maisemore Bridge, by the narrow footpath alongside the A4187 for half-a-mile before reaching the riverside footpath again which heads south for a further half-mile to Telford's Over Bridge, and meets the Geopark Way from Huntley and the Severn at Minsterworth. Alternatively, there are paths that cross Maisemore Ham and Alney Island that rejoin the Severn Way at Town Ham and Pool Meadow.

Thomas Telford designed the flat-arched Over Bridge opened in 1829; it still stands but is no longer used for traffic. Over Bridge was a crossing from Roman times, the A40 road bridge (built in 1974) and the railway bridge built in 1851 both follow the route of the Roman road Ermin Street from the west bank of the Severn. The railway bridge opened with the Gloucester & Dean Forest Railway, absorbed into the GWR in 1875. The Severn railway crossing at Over was a junction for the GWR Newent branch opened in 1885 and closed in 1964 it headed north, another short branch heading south went to Gloucester Docks opened in 1854 and closed in 1989. The narrower navigable eastern channel of the Severn flows towards Gloucester and Gloucester Docks, passing under Walham

The former dock railway crossing of the east channel of the Severn at Llanathony weir.

Bridge, the Newport Railway St Catherine's Viaduct and the three separate bridges at Westgate. The lock entrance to Gloucester Docks is at times tricky and vessels tie-up at the 'wall' of the Quay to prevent them from drifting into the strong river current that flows toward Llanthony weir and the Lower Parting.

The two channels rejoin at Lower parting Port Ham 1¾ miles further south.

The two channels of the the Severn form Alney Island with Port Ham to the south and Town Ham divided by the A417 that crosses between them, and Maisemore Ham north of the A40 road as it bisects Alney Island east west. Alney Island is a local nature reserve, flood meadow and

Road and footbridge crossings of the east channel at Westgate.

wet grassland managed through grazing cattle. The Geopark Way makes its way around Port Ham from Over Bridge to cross the footbridge over the east channel. Meeting the Severn Way going south at the swing-bridge and entrance to Gloucester Docks the Geopark Way continues to Gloucester Cathedral and the end of its 109-mile journey from Bridgnorth on the Severn.

GLOUCESTER

Gloucester was a Roman settlement called Glevm founded around AD 47, by AD 97 it was Colonia Nervia Glevensium and home to retired legionaries. Ermin Street (Ermin Way) crossed into South Wales at Over, near to the existing bridges. From the north a long distance British track – in part a Roman road – ran from through Droitwich (Salinae) Worcester (Branogena) and Tewkesbury roughly following parts of the present-day A38 road to cross Ermin Street at Gloucester.

Æthelred, Lady of the Mercians and daughter of Alfred the Great, founded the Abbey of St Peter at Gloucester in 681. The Mercian and West Saxon Burhs (or burg – fortified settlements) of the Kingdom of Mercia extended for almost the whole distance of the River Severn from the Welsh border at Chirbury (near Welshpool) to Shrewsbury, Bridgnorth, Worcester, and Gloucester. Gloucester formed Mercia's western border with the Kingdom of Gwent. After the Norman Conquest, Gloucester was held by a succession of feudal barons. Gloucester received a charter in 1155 from King Henry II, followed by a second charter that gave the burgesses (freeman of the borough) freedom of passage on the River Severn. By the Middle Ages Gloucester's Severn river-trade included cereals, fruit, cloth, and cider from the Vale of Gloucester, importing among other goods wine, and fish. Bristol, with access to the Severn Estuary, traded more with the inland river ports at Worcester, Bewdley, Bridgnorth and Shrewsbury, bypassing Gloucester, despite Gloucester

receiving the formal status as a port by Queen Elizabeth I in 1580. Few foreign ships visited Gloucester because of the difficulties of navigating the shallow tidal stretch of the Severn, reaching Bristol Harbour on the Somerset Avon was far easier and safer.

Gloucester developed as the principal port on the Severn when it became the Northern Terminus to the Gloucester and Sharpness Canal.

Gloucester has a long and colourful history, and a wealth of interesting historic buildings of different architectural styles, many inexorably linked with the river Severn. The City Museum and Art Gallery in Brunswick Road exhibits finds dating to the Roman occupation, and segments of Roman wall are at kings Walk and Clarence Street, in Eastgate Street is a viewing chamber of the town's defences, the historic docks, buildings connected with Robert Raikes, Medieval buildings and a Tudor merchant's house. Gloucester also has many ecclesiastical buildings of interest, apart from the cathedral there were a number of monasteries: Black friars (Dominican Order), Grey Friars (Franciscan Order) and White Friars (Carmelites) no trace of their monastery at Gloucester survives.

Gloucester Cathedral's history stretches back to when it was a religious site, founded by the Anglo-Saxon Osric in 679, then to when it became a Benedictine Monastery. The Abbey Church of St Peter was consecrated in 1100; the

The Cathedral tower and Gloucester skyline from Castle Meads on Alney Island.

The abandoned Llanathony lock, which once connected the east and west, channels of the Severn and allowed vessels to navigate the river between Gloucester and Sharpness with out recourse to using the canal.

Inset: Local footpaths the long distance Geopark Way and the Wysis Way between Offa's Dyke to the Thames Path meet at Alney Island.

Norman church was rebuilt in Gothic Perpendicular style, with fifteenth-century fan-faulted medieval cloisters. After the dissolution of the abbey the church was established as the cathedral in the diocese of Gloucester. Lady Chapel was reglazed with Arts & Crafts glass by Christopher Whall. Other ecclesiastic buildings at Gloucester include St Oswald's Priory, founded by Æthelflæd, the church survived dissolution of the monasteries, but was largely destroyed during the Royalist siege of Gloucester in 1643 in the English Civil War. Greyfriars Friary dates back to the thirteenth century, rebuilt in Perpendicular Gothic in the sixteenth century the friary was largely destroyed during the English Civil War, but part of the church remains. Nearby is St Mary de Crypt Church in Southgate Street, famed because the eighteenth century cleric George Whitefield preached his first sermon there. Of the thirteenth-century Dominican Blackfriars Priory, many of the buildings have survived around the cloistered courtyard, including the Scriptorium, a medieval library. St Mary de Lode, next to the cathedral, is believed to be the site of a church founded by the second-century saint Lucius, king of the Britons. Loade has an obvious connection with a ferry that obviously crossed the Severn nearby. Similarly, the distinctly truncated spire of St Nicholas' Church, named after the patron saint of sailors and ships, rises conspicuously above Westgate Street; during the eleventh century, it was known as 'St Nicholas of the Bridge' perhaps another connection with crossing the Severn.

Finally, close to the Severn and beside the towpath of the Gloucester & Sharpness Canal, which is also National Cycle Route 45 is Llanthony Secunda Priory an Augustinian priory founded in 1136. The site is adjacent to Gloucestershire College and Llanthony Business Park on the Llanthony Road between St Ann Way.

GLOUCESTER DOCKS AND THE SHARPNESS CANAL

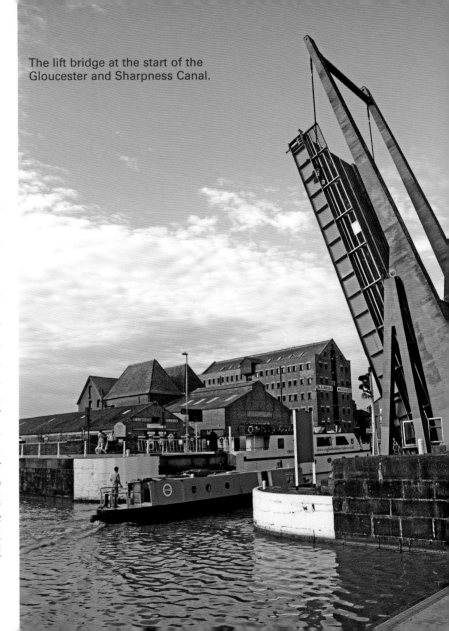

The lift bridge at the start of the Gloucester and Sharpness Canal.

The strong tidal currents in the Severn Estuary made navigation of the river especially hazardous, and the stretch below Gloucester was especially treacherous to sea-going vessels and river craft bringing raw materials and exporting finished goods to the port. The opening of the Gloucester & Sharpness Canal allowed ships to bypass the difficult stretch of river, and the port developed to accommodate the Severn river-trade and foreign ships. Gloucester is the most-inland port in the United Kingdom; today the quaysides at Gloucester have been redeveloped into a major tourist and local attraction.

An Act to construct a ship canal between Gloucester and Berkeley was passed by Parliament in 1793. Progress was initially slow due to delays caused by lack of funding, disputes between landowners, navvies, contractors and difficulties caused by the French War. By 1816, the canal was rerouted at Hardwicke, 6 miles south of Gloucester docks, to a course that brought it closer to the Severn and to a terminus at Sharpness, 2 miles above Berkeley Pill. The financial situation was resolved when the Exchequer Bill Loan Commission funded the project, they were set up under an Act of Parliament to promote public works and generate employment. Thomas Telford, who was one of the commissioners, acted as engineering consultant to the canal company. The loan was repaid in 1850 and the canal proved

Gloucester Docks showing wharves and warehouses.

profitable. The cut was 86 feet 6 inches wide and 18 feet deep, which allowed vessels of 240 feet in length, 30 feet in draft and of up to 600 tons to navigate, and pass each other between Sharpness and Gloucester. The canal opened in 1827 and at the time was the biggest canal in England Gloucester docks continued to develop, new warehouses and a dry dock built, The docks and canal declined in the 1960s, as remaining goods oil and petroleum imports ceased. Sharpness docks are still used, but there is little commercial traffic on the canal itself. Gloucester Docks is a favourite destination for visitors and shoppers the old warehouses at the quays have cafés, restaurants, bars and pubs, convenience store, gift stores, designer shops, antiques shops and even a microbrewery. The docks also have a number of events and attractions leisure cruises, visiting vessels, the Mariners Chapel, Gloucester Waterways Museum, Soldiers of Gloucester Museum and a working dry dock.

VALE OF BERKLEY

The Severn Way passes over Llanthony Road and turns into Hemmingsdale Road, passing in front of Llanthony Secunda Priory to resume its course down the Severn at the edge of Llantony weir. Passing over Sud Meadow the Severn Way follows the east channel to Lower Parting where the river meets the larger west channel. The course of the Severn meanders in a series of large loops around Hempstead coming to within 500 feet of the Gloucester & Sharpness Canal at Stonebench before both river and canal join up at Sharpness. The Severn continues its meander through the hamlets of Waterend, Bollow, Longney, and Epney where the river noticeably widens and the estuary starts to develop, and where the Severn now truly into its third age an 'Old River' is totally under the influence of the tides. Beyond Epney and Upper Framilode – yet another obvious name for a ferry– the meanders in the river take on names Upper Dumball, Lower Dumball and the Noose. Upper Frmilode not only takes its name from a ferry but from the river that flows into the Severn, the River Frome. It was also a canal port for the Stroudwater Canal, which crossed the Gloucester & Sharpness Canal at Junction Bridge, west of

the village of Saul. The Severn's meandering course takes it west from Upper Frampton over a series of sand bars to Newnham on the west bank, inside the loop of the river on the east bank is the village of Arlingham through which Passage Road passes. The road, probably Roman in origin, continued across the mud and shallows to Newnham and the Forest of Dean, it now stops on the banks of the Severn the ferry that accompanied the ford is also long gone.

The Severn Way on the west bank follows the river as it winds a course through mud and sand, passing a series of streams that steeply enter the Severn and over Hock Cliff, within 1½ miles the Severn Way leaves the estuary to resume its way south on the tow path of the Gloucester & Sharpnesss Canal at Frampton on Severn. The Severn Way continues on the Gloucester and Sharpness Canal for a further 7 miles to the 'Old Dock' and abandoned locks at Sharpness Docks. The Severn flows around Awre on the west bank and bulges out into a wide sandy estuary in two channels over the tidal sands of the Noose. The east channel passes through Frampton Breakwater, Black Rock Breakwater and Middle Breakwater before passing by the Wildlife and Wetland Trust at Slimbridge. Rejoining the west channel over Frampton Sand, Waveridge Sand and The Ridge Sand the Severn reaches the river lock at Sharpness Point.

Above right: The Anchor Inn Altney.

Right: The Severn as it becomes an 'Old River' following its wide 'u' shaped valley to the estuary.

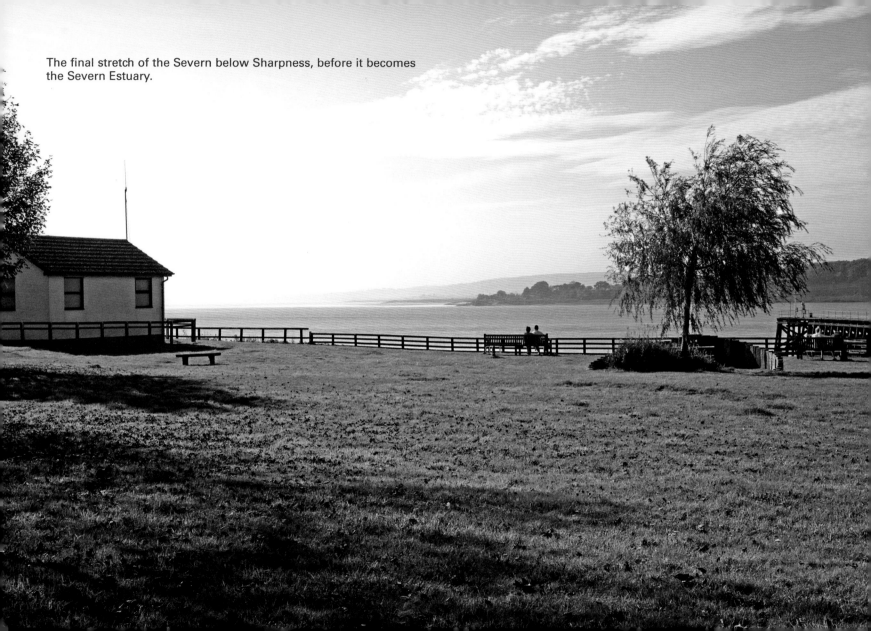
The final stretch of the Severn below Sharpness, before it becomes the Severn Estuary.

7
SHARPNESS AND THE SEVERN ESTUARY

There is no absolute definition for where the River Severn ends, where the Severn estuary (mouth of the Severn/Aber Hafren) starts and ends, or where the Bristol Channel starts and ends. The boundaries may be politically defined by governments, environmental agencies, basin and river catchment districts, wildlife organisations, maritime organisations, maps, admiralty charts or just by tradition. The River Severn is usually considered to end at the second Severn Bridge, the crossing between Severn Beach and the English Stones in Gloucestershire and the Bedwin Sands at Sudbrook in Monmouthshire. The Bristol Channel Môr Hafren (Severn Sea) seperates South Wales and England, and extends from Weston-super-Mare and Penarth near Cardiff to the Celtic Sea. Together the Bristol Channel and Severn estuary form one of the largest tidal ranges in the world 39 feet (12 metres), with shifting sand banks, exposed rocks and fast tidal currents, navigation and crossing the estuary was fraught with risk. Strong tidal currents in the estuary and tidal reaches of the Severn are not the only hazard. The famous Severn Bore, a wave that travels upriver, was also once a hazard to navigation, although vessels navigating below Gloucester relied on the tides especially, conditions of fortnightly spring tides to reach Upton-upon-Severn.

The tidal range of the Severn has since been diminished to Gloucester with the building of the weir at Maisemore, and the risk of navigation on the Severn was further reduced when the Gloucester and Sharpness Canal was opened to bypass this hazardous stretch of the river. The Severn Bore at times is an impressive tidal wave that travels 20 miles up the Severn Estuary between Awre and Gloucester. The bore forms when Atlantic tides enter the narrowing estuary and river, the narrowing banks and shallowness of the channel cause the water level to rise into a wave as the natural flow of the river is reversed. The bore can best be seen from the west bank at Newnham, the Severn Bore Inn on the A48, Minsterworth, Over Bridge, Maisemore or from the east bank at the Anchor Inn at Epney.

There are two road bridges that cross the estuary and there were once two railway crossings, the railway viaduct between Sharpness and Lydney was partially destroyed

120 RIVER SEVERN

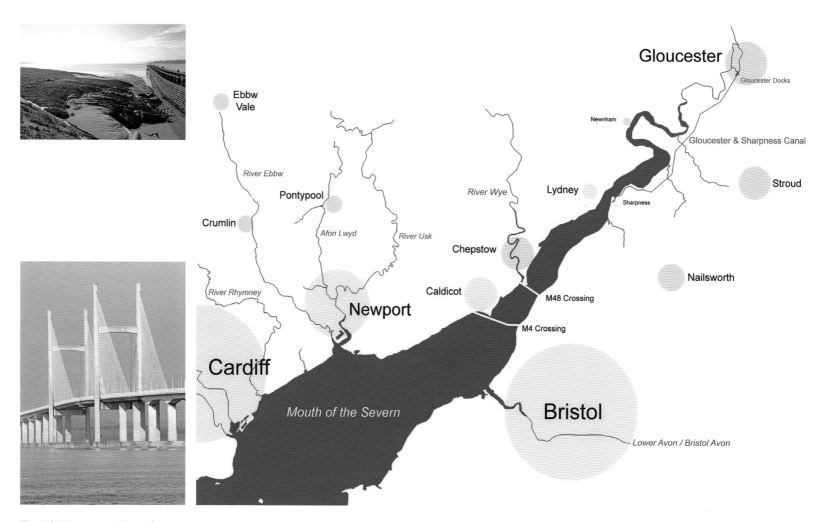

The 'Old' mature River Severn at the entrance to Sharpness Docks and the pillars of the second Severn Bridge mark the end of the river.

and subsequently dismantled in the 1960s, though the GWR railway tunnel between New Passage and Sudbrook is still in use.

The pilotage of vessels approaching the Sharpness entrance to the canal was originally the responsibility of Bristol and Trinity House, and transferred in 1861 to the Gloucester Pilotage Board. The customhouse at Gloucester was relocated to Sharpness when cargo handling declined at Gloucester after a new dock capable of handling larger vessels was built at Sharpness in 1874. The provision of lights in the estuary came under the jurisdiction of the Gloucester Harbour Authority formed in 1890. Today Gloucester Harbour Trustees based at Sharpness are responsible for pilotage and lights in the estuary.

Environmentalist considered the estuary to be a major important wetland and natural habitat for migrating colonies of birds, and a wild life environment. There are numerous SSSI covering grassland and mud flat habits and environments in the estuary. The estuary's tidal range is also considered to be a massive unexploited natural energy reserve. The future of the estuary will therefore be subject to great debate as environmentalists and supporters of renewable wave and wind power argue their relative viewpoints.

SHARPNESS

The treacherous nature of navigation on the coastal Severn with fast tides and poor visibility in dense fog was demonstrated in one tragic incident in the 1960s. The Severn & Wye and Severn Bridge Railway, was operated as a joint line operated between the Midland Railway and GWR railways, serving connections with the GWR South Wales main line and the Midland's Bristol & Gloucester lines. One of the greatest engineering challenges for the Severn & Wye Railway was crossing of the Severn, which was achieved by the construction of an impressive railway bridge. The Severn & Wye line approached the river Severn on a 13-arch masonry viaduct from the west bank, and crossed on two spans of 327 feet supported on pier cylinders over the navigable channel, with nineteen lesser spans supported on columns with a swing bridge over the Gloucester & Sharpness Canal at its eastern end. On Tuesday 25 October 1960, the bridge was severely damaged when a stricken petrol tanker hit one of the supporting pillars. The incident occurred between two fuel tankers one towing barges both missed the entrance to Sharpness Docks, the vessels became entangled and drifted up river with the tide, both collided into a bridge support and exploded destroying two sections of the bridge, with the loss of five lives. The bridge was never repaired the bridge was dismantled, and the line was later lifted. The Severn and Wye to Lydney closed, but the extensive railway sidings surrounding the docks testify to the former importance of Sharpness as a port and railway transhipment point.

The original old Sharpness basin and dock giving access to the Gloucester and Sharpness Canal opened, with

the canal, in 1827. At first, there were no port facilities and vessels proceeded directly to the customs facility at Gloucester

The basin was semi-tidal separated from the river by a single river lock gate, and two additional locks connected to the Old Dock and canal. The two locks comprise of a ship lock of 163 feet long and 38 feet wide, and a second smaller lock for trows of 81 feet long and 19 feet wide.

Sharpness was redeveloped in 1874 when a larger new floating dock was added. The entrance from the Severn was through a 320-foot-long 57-foot-wide ship lock into a tidal basin held at the level of the canal. A dry dock was also built beside the two inner locks, and subsequently warehouses, storage silos, two railway bridges and extensive sidings on both the island- and land-side quays of the dock. The Old Dock river lock entrance was abandoned at the beginning of the twentieth century, and permanently sealed in the last decade of the twentieth century, and the inner locks were made redundant as the water level of the Old Dock was now permanently at the same level as the canal.

There were two railway swing bridges across the dock the low-level bridge still caries rails, and the high-level bridge, now carries the road and Severn Way south, on

Above: The former Severn & Wye Joint GWR and Midland Railway upper swing bridge the rails crossed two viaducts and brought coal trains from the Forest of Dean collieries for loading from coal shoots at the island Quay.

Below: View of the Floating Dock.

the landward side of the docks. The Midland and GWR companies operated a joint line between Sharpness and Lydney in the Forest of Dean on the West bank, and the Bristol and Gloucester line on the east bank of the Severn. Both companies had running rights on each other's lines, which were rationalised after nationalisation under British Railways. The line to Lydney closed in 1964 after the Severn Bridge disaster, but the railway connection from Sharpness Docks to the Bristol and Gloucester line still exists, as do the railway sidings at Sharpness, which have seen no railway traffic to the docks since the late 1960s. The line outside the docks remains in use for the transportation of nuclear flasks from Berkeley Power Station. The 4-mile stretch of railway is an ideal candidate for railway preservationists, and a newly formed Vale of Berkeley Railway (VBR) plans to restore part of the route as a steam heritage railway between rebuilt stations at Sharpness and Berkeley. In the final years of the twentieth century, petroleum and oil tanker traffic had dwindled away in the 1960s, and ships stopped entering Gloucester in the 1980s. Sharpness remains open as a port, transhipping bulk cargoes of cement, fertilizer and scrap

Above: The tidal basin and entrance to the floating dock at Sharpness.

Below: The picnic area at Sharpness, a suitable spot for a break on the Severn Way long distance path.

metal by road, while the Sharpness and Gloucester Canal is used exclusively by pleasure craft.

It is far easier to follow the course of the river Severn on the east bank from Sharpness. Few paths get close to the river on the west bank. Instead, the course of the Severn is closely followed by the South Wales main line and the A48 between Lydney and Chepstow Road. The Severn Way continues south along Oldminster Road and crosses the occasionally used railway loop outside the dock, crossing the B4066 road it enters onto the riverside-grassed park and picnic area beside the piers and southern entrance to Sharpness Docks, across the Estuary are Lydney and the Forest of Dean.

OLDBURY

Heading south along the east bank of the river the Severn Way heads inland to avoid Berkeley Pill and the nuclear power station above Bull Rock. The Magnox-designed power station is undergoing a lengthy decommissioning process that will result in its final demolition and clearance of the site between 2070 and 2080. From the breakwater

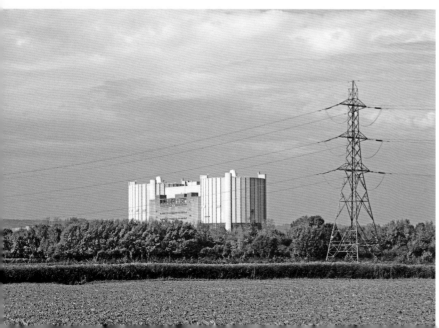

Above: The power lines of the nuclear power station are perhaps a foretaste of the future, as plans for tidal and wind power are openly discussed, the Severn riverside could soon have to accommodate the electricity transmissions pylons that such schemes require.

Below: The nuclear power station at Oldbury.

on the west bank it is possible to see across Lydney and Saniger sands to the slipway and lock entrance to Lydney Harbour on the west bank of the river. In 4 miles the Severn Way arrives at the tidal reservoir of a second nuclear power station at Oldbury-upon-Severn, this time very much operational, the Severn Way path passes between the power station and the river. Within 1½ mile, the Severn Way once again departs the bank of the river to head into the village of Oldbury-on-Severn avoiding Oldbury Pill. From the Anchor Inn in the village, the Severn Way returns to the east bank of the river on the opposite bank of Oldbury Pill, in 3 miles it arrives at the Old passage and the first of the Severn road bridges.

THE OLD PASSAGE AND THE NEW PASSAGE & SEVERN ESTUARY

The first Severn Bridge is an impressive structure with a main span of 3,240 feet it was built in 1966 and now carries the M48 South Wales-London road. The bridge spans between Wales and England over Aust Rock, Great Ulverstone Rock, and the Severn at a pinch point between Beachley a spit of land that forms the west bank of the Severn and east bank of the River Wye. The crossing continues across the confluence of the River Wye and rejoins the west bank of the Severn in Wales.

A ferry once operated between Beachley landing Pier and the Old Passage, it closed in around 1860, the service was resumed in 1926, and finally closed with the opening of the bridge in 1966. An increase in traffic led to construction of the second equally impressive Severn crossing carrying the M4 motorway. The crossing at Severn Beach is over three miles long and connects South Wales and England. The 500-yard central span is cable-stayed, held between two massive pylons. The approaches are by viaducts at Caldicut in South Wales, then over the bridge and Cuggy stones and the English Stones to New Passage on the east English side of the river Severn. One other invisible crossing also crosses the Severn, The Severn Railway Tunnel opened in 1886 connects the South Wales main line to London it passes under the Severn from a tunnel mouth and deep cutting at New Passage to re-emerge at Sudbrook and Severn Junction station at Caldicot in Wales. Severn Beach is the official end of the Severn Way long-distance path from the source of the Severn to the Sea, the last bridge crossing is also generally considered the end of the River Severn and the true beginning of the Severn Estuary.

The Old Passage and the huge electricity pylon that carries power cables over the Severn.

The New Passage and the end of the River Severn as it reaches its estuary and the sea.

FURTHER INFORMATION

Canal and River Trust https://canalrivertrust.org.uk/ is a registered charity responsible for looking after the 2,000 miles of waterways in England and Wales.

The Inland Waterways Association (IWA) https://www.waterways.org.uk is a registered charity that advocates the conservation, maintenance, restoration of all inland waterways for public benefit.

British Canoeing (BCU) http://www.bcu.org.uk/about/ the UK organisation to promote canoeing.

The Long Distance Walkers Association web site offers useful information on long distance walks https://www.ldwa.org.uk

The preserved Severn Valley Railway runs alongside the River Severn between Bridgnorth and Bewdley http://www.svr.co.uk/

Sustrans and the national Cycle network that offer a number of routes alongside the Severn http://www.sustrans.org.uk/

The Environmental Agency https://www.gov.uk/government/organisations/environment-agency

Natural England https://www.gov.uk/government/organisations/natural-england

BOOKS AND ESSENTIAL MAPS

The Severn Way, *The Longest Riverside Walk in Britain Official Walkers Guide*, ISBN 1-902999-00-2

Explorer Series OS Maps Scale 2.5 inches to 1 mile (4cm to 1km) in order from source to the estuary

Ordnance Survey Explorer 214 Map Llanidloes & Newtown, ISBN 978-0-319-24407-4

Ordnance Survey Explorer 216 Map Welshpool & Montgomery, ISBN 978-0-319-24409-8

Ordnance Survey Explorer 240 Map Oswestry, ISBN 978-0-319-24433-3

Ordnance Survey Explorer 241 Map Shrewsbury, ISBN 978-0-319-24434-0

Ordnance Survey Explorer 242 Map Telford, Ironbridge & The Wrekin, ISBN 978-0-319-24435-7

Ordnance Survey Explorer 218 Map Kidderminster & Wyre Forest, ISBN 978-0-319-24411-1

Ordnance Survey Explorer 204 Map Worcester & Droitwich Spa, ISBN 978-0-319-24397-8

Ordnance Survey Explorer 190 Map Malvern Hills & Bredon Hill, ISBN 978-0-319-24383-1

Ordnance Survey Explorer 179 Map Gloucester, Cheltenham & Stroud, ISBN 978-0-319-24372-5

Ordnance Survey Explorer OL14 Map Wye Valley & Forest of Dean, ISBN 978-0-319-24253-7

Ordnance Survey Explorer 167 Map Thornbury, Dursley & Yate, ISBN 978-0-319-24360-2

Ordnance Survey Explorer 154 Map Bristol West & Portishead, ISBN 978-0-319-24347-3